PAINTING
OUTDOOR SCENES
IN WATERCOLOR

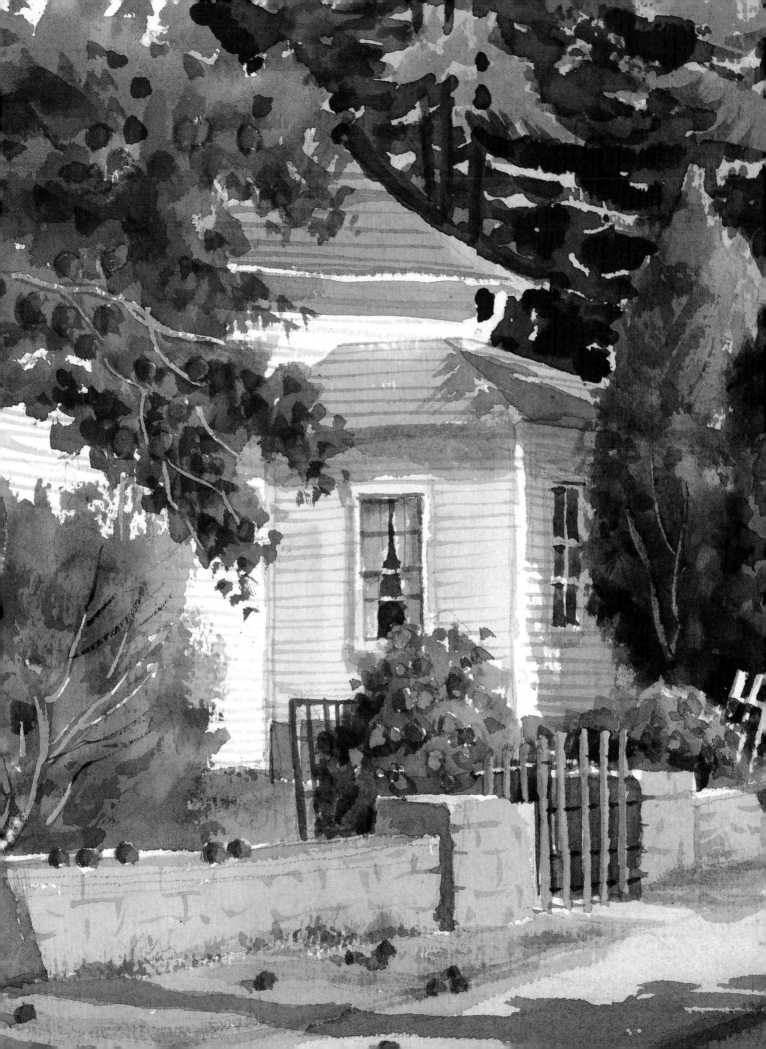

PAINTING
OUTDOOR SCENES
IN WATERCOLOR

RICHARD K. KAISER

NORTH
LIGHT
BOOKS

Cincinnati, Ohio

ABOUT THE AUTHOR

Richard K. Kaiser, a graduate of the Art Institute of Pittsburgh, has studied under John Pike, Zygmund Jankowski and Tony Van Hasselt. His paintings are in many private and corporate collections worldwide and he has had several one-man shows. His paintings are shown at galleries in Colorado, North Carolina and New Jersey.

He also teaches watercolor classes, drawing and composition, watercolor workshops and life drawing, both privately and for several adult school systems.

Dick Kaiser is an associate member of the American Watercolor Society and a member of the National Academy of Design, the Garden State Watercolor Society, and the Artists League of Central New Jersey, which twice selected him to serve as artist-in-residence in watercolor.

Painting Outdoor Scenes in Watercolor. Copyright © 1993 by Richard K. Kaiser. Printed and bound in Hong Kong. All rights reserved. No part of this book may be reproduced in any form or by any electronic or mechanical means including information storage and retrieval systems without permission in writing from the publisher, except by a reviewer, who may quote brief passages in a review. Published by North Light Books, an imprint of F&W Publications, Inc., 1507 Dana Avenue, Cincinnati, Ohio 45207. 1-800-289-0963. First edition.

97 96 95 94 93 5 4 3 2 1

Library of Congress Cataloging in Publication Data

Kaiser, Richard K.
　Painting outdoor scenes in watercolor / by Richard K. Kaiser.
　　　p.　　cm.
　ISBN 0-89134-460-8
　1. Landscape painting—Technique. 2. Watercolor painting—Technique. I. Title.
　ND2240.K35　1993
　751.42'2436—dc20　　　　　　　　　　　　92-30946
　　　　　　　　　　　　　　　　　　　　　　　　　　　CIP

Edited by Rachel Wolf and Kathy Kipp
Designed by Clare Finney

Demonstration photography on pages 107-113 by Tom Hodge.

Dedicated to the memory of my parents, Emma and George Kaiser, who knew what I wanted to do with my life and helped me attain it.

ACKNOWLEDGMENTS

My wife, Carol, has backed and helped me in all my work. Her encouragement made this book possible. Many thanks to Greg Albert and Rachel Wolf, who said they would guide me and walk me through the writing of this book—and did it so well. I would like to acknowledge my first "profs" from art school days, Harry Hickman and Vincent Nesbert. A special note goes to the late John Pike who, as one of my latter-day "profs," opened my eyes and guided my paintbrush. My thanks, too, to Zygmund Jankowski who constantly challenges me to do the better thinking required for better paintings. My sincere appreciation to those special friends who, through their encouragement and constructive critiques, have helped me to be a better artist—Harry Madson, Tony van Hasselt and Charlie Movalli. Last but not least I thank all my students who, by asking questions, expand my talent.

CONTENTS

Introduction
viii

CHAPTER ONE
KNOWING YOUR MATERIALS
Get to know the materials you need for outdoor and indoor landscape painting. Drawing Supplies • Paint • Brushes • Paper • Palette • Miscellaneous • Easels • Painting Outdoors
2

CHAPTER TWO
DECIDING WHAT TO PAINT
Try this proven method for finding and choosing the best scene. Finding A Scene • Walk Around It • Use a Viewfinder • Ask Yourself Questions • Put Your Ideas On Paper • Choose the Best
14

CHAPTER THREE
DESIGNING A SUCCESSFUL PAINTING
Learn how to translate a beautiful scene into a powerful painting. Arranging Shapes • Variety • Positive and Negative Shapes • Silhouettes • Vignettes • Entrances and Exits • Arranging Values • Create a Target • Putting It All Together • Miniwatercolors • Using Photographs • Step-by-Step Demonstrations
24

CHAPTER FOUR
ADDING SEASONAL COLOR
Discover how to convey each season by using a unique palette of colors. Color Basics • Questions to Ask • Color for the Seasons • Winter • Spring • Summer • Fall
46

CHAPTER FIVE
PUTTING LIGHT IN YOUR LANDSCAPE
See how using light correctly can make your paintings more realistic and more expressive. Toplight • Backlight • Side Light • Foggy Day • Bright Day • Rainy Day • Twilight • Night • Reflected Light • Inside, Looking Out
56

CHAPTER SIX
LANDSCAPES—STEP BY STEP
Watch these five watercolor demonstrations go from sketch to finished painting. Painting Cast Shadows • Saving Sparkling Whites • Creating Depth • Contrasting Sunlight and Shadows • Painting Varied Textures
78

CHAPTER SEVEN
IMPROVING YOUR PAINTINGS
Use this guide to critique your paintings—and to fix them once you know where they need improvement. Critiquing Your Work • Correcting Techniques • Cropping • Glazing • Scrubbing • Misting • Postcard Cutouts • Lifting • Spatter • Practice Scenes and Studies
100

CHAPTER EIGHT
PAINTING IN DIVERSE SETTINGS
These paintings from various locales will inspire you to paint more outdoor scenes. By the Sea • Cool Forest Streams • Around Town • Mountain Vistas • Farmlands
118

Final Thoughts 132

Index 134

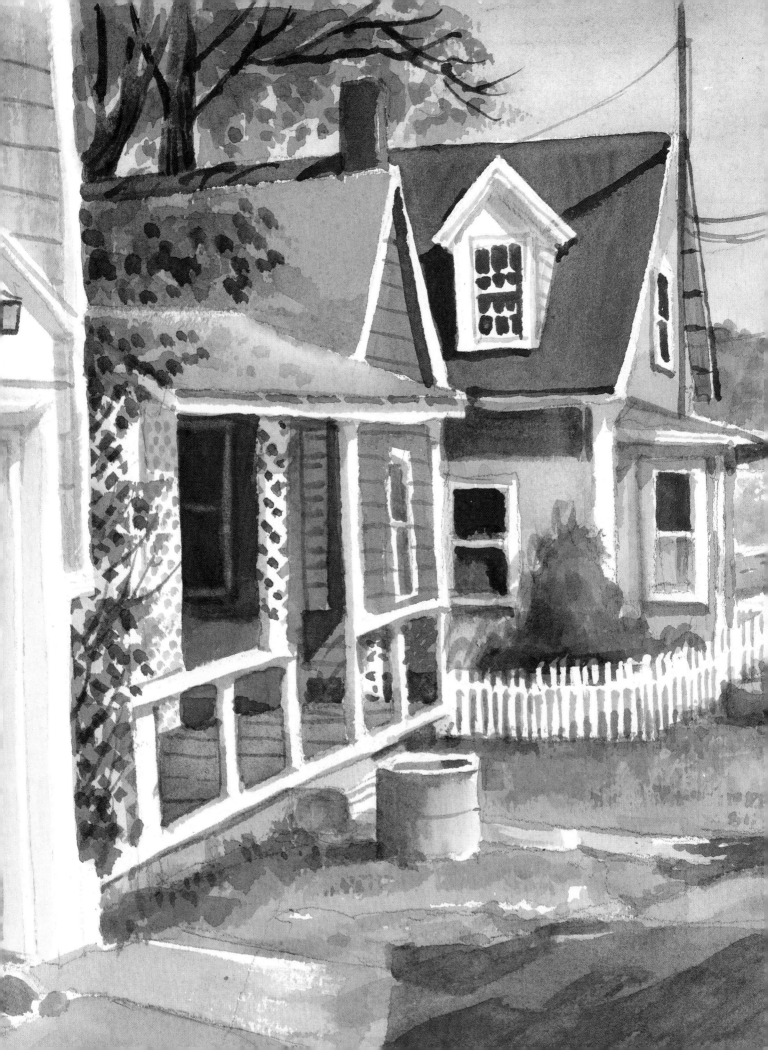

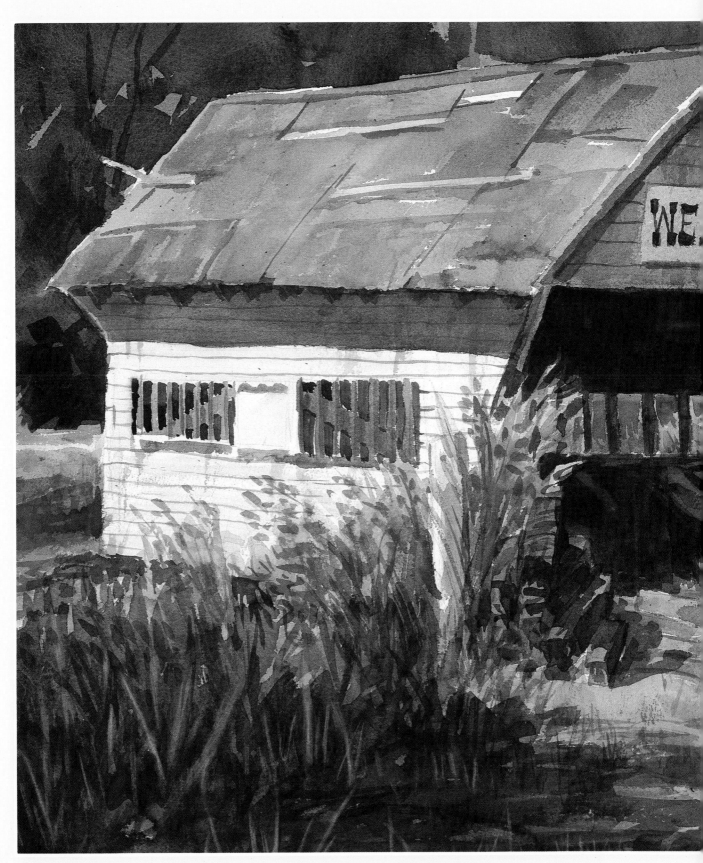

COVERED BRIDGE—SWIFTWATER INN, POCONO PINES, PENNSYLVANIA, 22×30″

INTRODUCTION

From the Impressionists to the artists of the Hudson River school, painters have used depictions of nature—usually of their own surroundings—to express their feelings and moods. The almost transcendent feeling of a particular place at sunrise, noon, or even in the rain is what inspires many of us to paint. Trying to capture that feeling—the feeling of a landscape—in watercolor can be frustrating, to say the least. But it *can* be done.

Watercolor needn't scare you. In this book I intend to give you practical, helpful assistance and, I hope, inspire you to paint those scenes that stir your imagination.

I don't know how much talent you have, how much you know, or how hard you will work to be a watercolor painter. That's all up to you. Painting watercolors can be a lifelong occupation.

In this book, simple step-by-step demonstrations and explanations take you from the beginning to the finished painting. I will show how to develop the most popular subjects in watercolor landscapes and discuss what to look for in a subject, what to change, how and when to let the light set the mood of the scene, when to explore rich color, and when to stop. I will also show you when and how to finish an outdoor painting at your home or studio.

Over the course of quite a few years, I've been befriended by many nationally famous artists who have helped me with both instruction and encouraging words. Throughout this book I will share some of their comments and thoughts that have been particularly helpful to me. Maybe these ideas will help you, too.

So, let's get into the work of making a watercolor. Yes, work—but fulfilling work that captures the landscape and expresses your individual moods, thoughts and insights.

R.K. KAISER

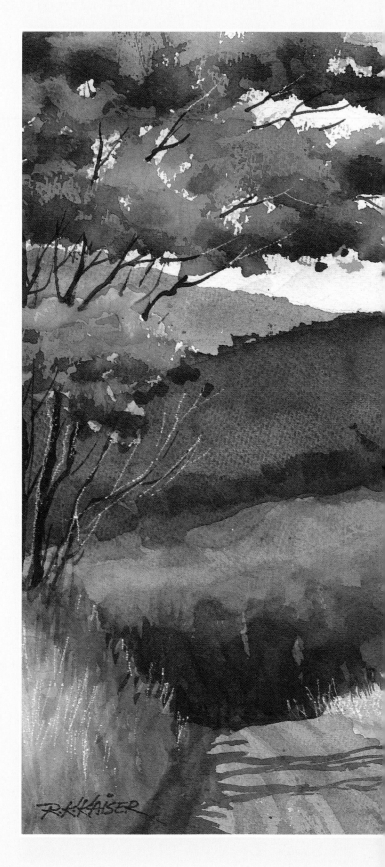

CHAPTER ONE

KNOWING YOUR MATERIALS

Over the years I've used hundreds of different types of materials. As an illustrator, I sometimes used four or five different media to finish one illustration. Knowing how to use many different materials has helped me become a better water-colorist.

But it is the artist behind the brush or pen-cil—with that special outlook and unique hand—who makes the painting. Even after you've seen and perhaps tried many of the artist's supplies available, it still boils down to just you, your hand and your brush making the finished painting. Knowing your materials, and what they can do for you, is a must.

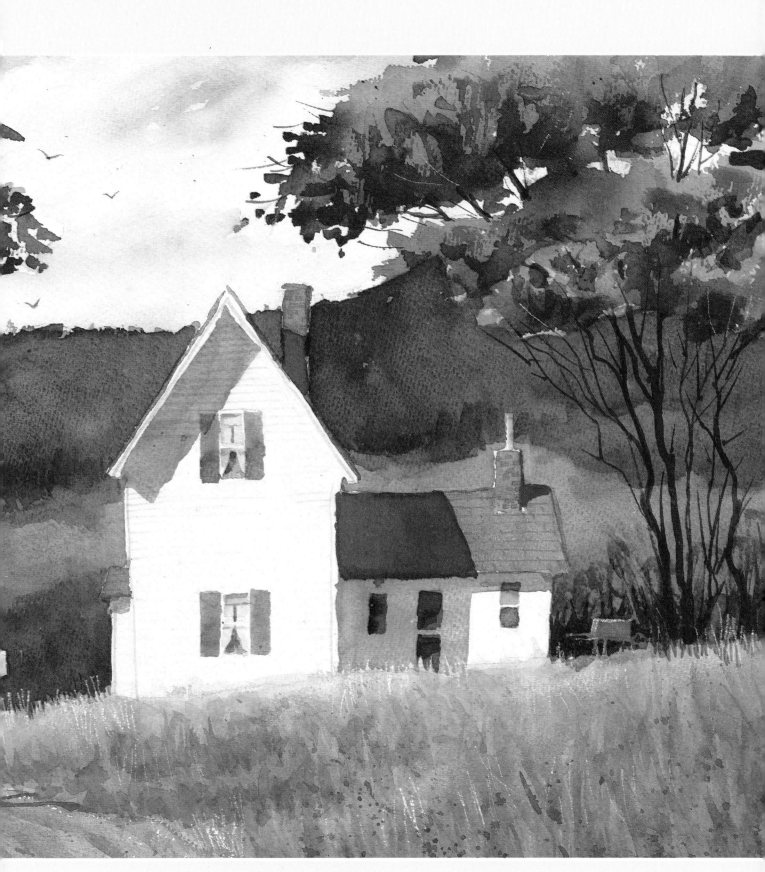

THE FARM, DORSET, VERMONT, 15×22"

MATERIALS

Keep a sketchbook with you always. Draw constantly. Drawing any subject will let you know it thoroughly. If you don't paint or draw trees well, take your sketchbook outdoors, sit in front of trees and draw them. Draw big trees, small bushes and weeds. After drawing lots of them, you will know the types and characters of trees. If the subject you are drawing doesn't look right or doesn't have that touch of authenticity, it's probably because you've never really studied it. You can't paint a barn if you've never seen one. Don't fake it! Your painting of a barn will be seen by people who *know* barns, and it will stand out like a sore thumb if it's incorrect.

DRAWING SUPPLIES

Most of the time I use a 9 × 12-inch sketchbook with a hundred pages of 60-lb. paper, usually paper with a little tooth to it. The sketchbook has a heavy cardboard backing, and I attach another piece of heavy cardboard to the front cover. This gives me a sketchbook that I can stand up (like an A-frame) to view my sketch later at home or in my studio.

I use various pencils and markers for sketching. My pencil preferences: flat—General's Sketching Pencils in 2B, 4B, 6B; and rounds—Berol Veriblack 315; Ebony, Jet Black, Extra Smooth 6325; Staedtler Mars Lomograph, 100EE.

I use Design Art Markers (wedge-edged) in black; gray no. 2, 229-L2; and gray no. 5, 229-L5. For a great brush feel and a thin line, I use Staedtler Mars Graphic 3000 Duo—which has a brushlike form on one end and a thin normal line nib on the other—no. 9 (black), no. 84 (light gray) and no. 82 (medium gray).

Use the drawing tools that you are comfortable with and that give you what you want. A minute spent drawing will help you understand your subject and is never wasted. I put notes on the side of my sketch to help me remember color, local objects, where the light is coming from, and other important data.

Flat Sketching Pencil

Normal #2 Pencil

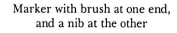

Marker with brush at one end,
and a nib at the other

Berol or good heavy black pencil

PAINT

I prefer tube paint for my palette. There are many brands out there — choose one that has been around for a few years and that gives you the best pigment. You don't have to buy the most expensive paint, but don't start out too cheap. Buy a cheaper tube of, say, alizarin crimson, then buy another, more expensive tube. Try both with water and brush. You will see the difference when you put them on the paper. Remember the old adage, "You get what you pay for!"

For the purposes of this book, you need to buy *transparent* watercolor, not tempera, gouache or casein, which are water soluble but opaque. Whatever you buy, make sure it won't fade in a few years. Most major brands are permanent, but read the labels to make sure.

Below are some of my favorite hues of tube paints.

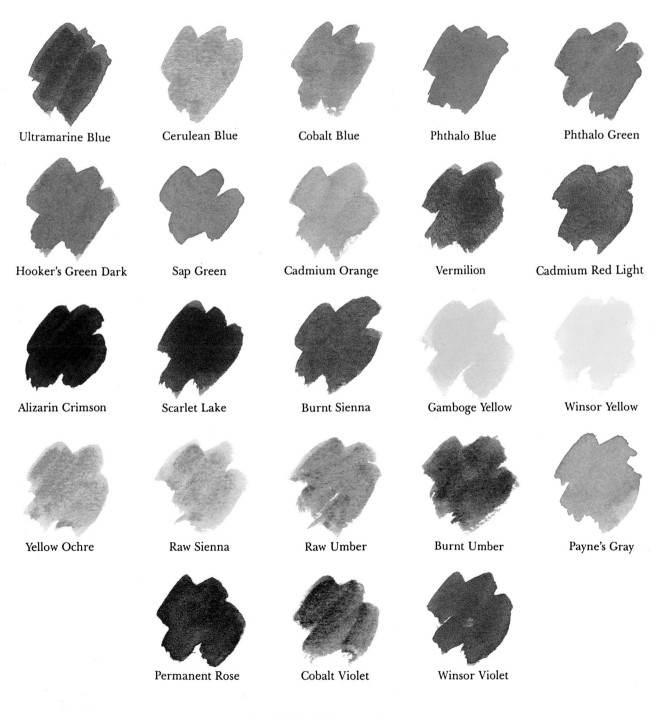

Ultramarine Blue	Cerulean Blue	Cobalt Blue	Phthalo Blue	Phthalo Green
Hooker's Green Dark	Sap Green	Cadmium Orange	Vermilion	Cadmium Red Light
Alizarin Crimson	Scarlet Lake	Burnt Sienna	Gamboge Yellow	Winsor Yellow
Yellow Ochre	Raw Sienna	Raw Umber	Burnt Umber	Payne's Gray
Permanent Rose	Cobalt Violet	Winsor Violet		

BRUSHES

Brushes are personal things. I have an artist friend who uses a brush that looks like a mop but uses it masterfully and produces superb paintings.

There are two definite brush shapes: flats, which have square chisel-like ends, and rounds, which are bulbous and end in a point. Brushes come in all different sizes. The flats range from ¼ to 4 inches wide. The rounds range from no. 000 to no. 36.

In the flats I use the ⅝-inch, ¾-inch, 1-inch, 1¼-inch, 2-inch, 2½-inch, 3-inch and a large 4-inch Hake Oriental brush for wetting large watercolors. In the rounds I use a no. 4, 8, 10, 12 or 14 and a Robert Simmons no. 26 and no. 36. I also use a no. 6 rigger (liner brush), which is a slim, extra long brush used for detail and calligraphy and to make great lines for tree branches. It is springy and holds a very sharp point. I also use

a no. 6 oil painter's fan brush for spatter work and an inexpensive stipple brush for scrubbing out areas and, occasionally, stippling.

I usually paint with as large a brush as I can in the beginning—getting down big shapes and areas and forcing myself to paint as *simply* and *boldly* as possible. I've often said you should try to paint one whole painting with a 1-inch flat or a big brush, just to learn to control and simplify your painting. Your painting should be done in a few minutes; then you can finish it with a small brush, defining details. Remember: Less is best. Like everyone else, I am always tempted to do "just *one* more stroke," that one stroke that will miraculously finish the painting. We all fall into that trap.

When buying brushes, don't rely on the store clerk's advice. Make sure you know the size, make and model number of the brush you want. And don't take "Oh, don't worry, this brush is just as

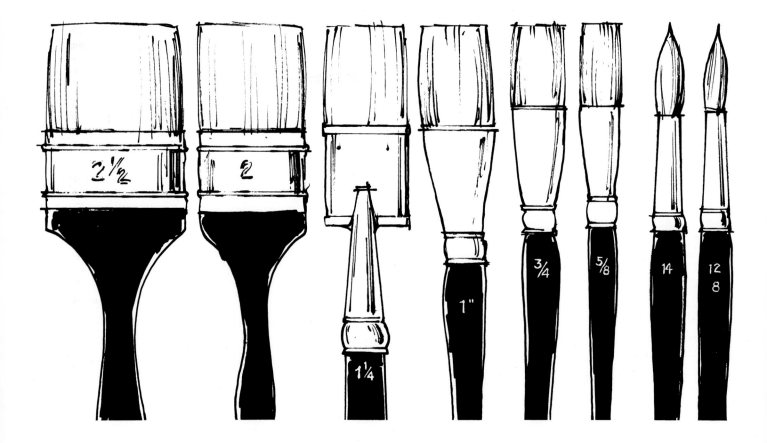

good." You'll be sorry in the long run. Buy the best brush you can afford. A brush is worth the extra money if it helps you make a good painting.

PAPER

I usually use Arches 300 lb., cold press, and Arches 140 lb., cold press, and in some cases, rough. Use the best you can afford—it will give you better results.

There are many different brands on the market, and you should try them all. Each one will produce different results. Some have a whiter surface, some a slight eggshell color; some are buff. Cold press, hot press and rough are the same in any make of paper.

Also, the texture is the same in all weights of paper. Paper is available in 400-, 300-, 140-, and sometimes 75-lb. weights. I don't have to worry about 300-lb. paper buckling when I put down a very wet wash. But the 140-lb. paper won't buckle if you stretch it by wetting it and staple it to a board. Soak the paper in water (both sides) or under a faucet, then mount it to a board. I staple it one-half inch in from the edge and place the staples one inch apart—any farther apart would defeat the purpose of stretching. Of course, you can use tacks, clamps, tape or anything else that works. Use the brown paper glue-backed tape you find in a stationery store, not masking tape; masking tape will not hold the paper when it shrinks. The paper will stretch slightly when wet; then when it dries, it will contract like a drumhead and be very easy to paint on. The stretched paper should buckle very little when a very wet wash is put on it. Since the 300-lb. paper usually costs twice as much, you save money buying 140-lb. paper and stretching it.

Most papers come in imperial size (22 × 30-inch) sheets, and in quires of twenty-five sheets. They also come in blocks of twenty to twenty-five

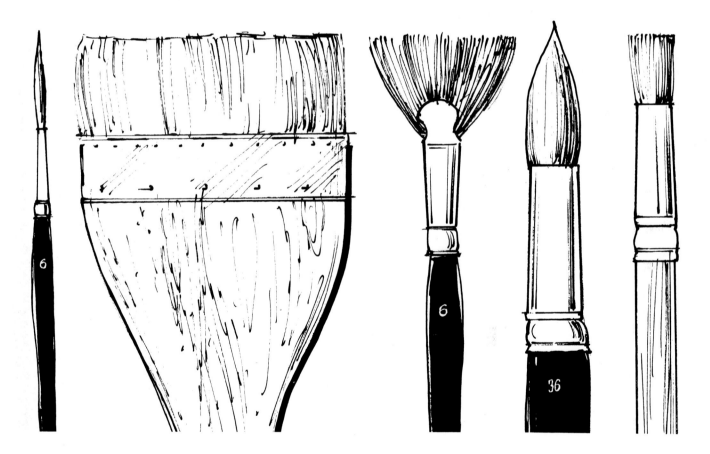

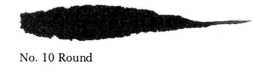

No. 10 Round

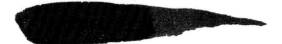

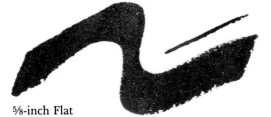

No. 14 Round

2½-inch Flat

⅝-inch Flat

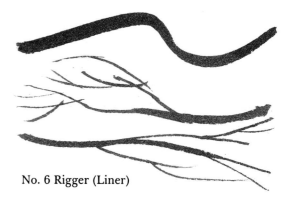

¾-inch Flat

No. 6 Rigger (Liner)

1-inch Flat

No. 6 Fan Brush (Oil)

Here are some of the brushes I use, and the different strokes and washes you can achieve with them. Notice how thick and thin a line you can get by varying your pressure on the brush. You can use both flats and rounds in a sideways stroke for a lot of different effects. Notice also the thin line you can get with the flats.

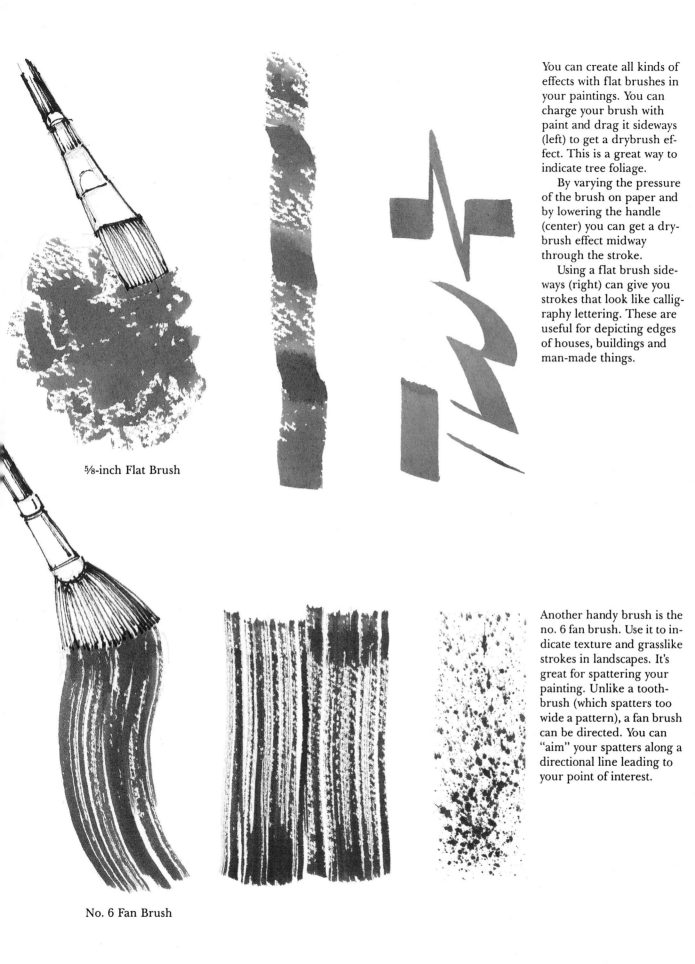

You can create all kinds of effects with flat brushes in your paintings. You can charge your brush with paint and drag it sideways (left) to get a drybrush effect. This is a great way to indicate tree foliage.

By varying the pressure of the brush on paper and by lowering the handle (center) you can get a drybrush effect midway through the stroke.

Using a flat brush sideways (right) can give you strokes that look like calligraphy lettering. These are useful for depicting edges of houses, buildings and man-made things.

⅝-inch Flat Brush

Another handy brush is the no. 6 fan brush. Use it to indicate texture and grasslike strokes in landscapes. It's great for spattering your painting. Unlike a toothbrush (which spatters too wide a pattern), a fan brush can be directed. You can "aim" your spatters along a directional line leading to your point of interest.

No. 6 Fan Brush

sheets. These are held together on all four sides with glue. They can be separated with a pocket knife.

The bottom line: Use good paper. Don't stint on quality. In the long run it will pay off. Your paper should be able to take a beating, to hold up under scrubbing, scratching, and the hard labor of glazing over. Above all, it should do what you want it to do.

PALETTE

Although there are numerous different palettes on the market now, a few years ago there weren't many to choose from. They were typically made of metal, with small wells. Unfortunately, the metal usually rusted, and the small wells made you paint small watercolors because you couldn't get a big brush in them.

I use the John Pike palette—not because I knew John, but because I've seen the rest. His is still the choice of most professional watercolorists. I call it the "Cadillac of palettes." Constructed of space-age plastic, it's very strong and gives you two great areas for mixing. The twenty wells are deep and wide enough for big brushes.

You can always use two white plates—one for paint, one for mixing—or a butcher tray for a palette. Try to find a tray that keeps the paint from running down into your mixing area and creating a color you don't want or, even worse, a muddy mess.

People often ask, "What palette should I use for indoor and outdoor painting?" There is no reason to change your palette for your locale. Again, use what works best for you. I use my Pike palette both indoors and out. However, I do use a smaller one to paint smaller outdoor studies, one of the new metal "Holbein"-type folding palettes. Folded, it measures 5½ × 12-inches and has twenty-eight small square wells. Open, it's 10¾ × 12-inches, a pretty good size for mixing your paints.

MISCELLANEOUS

• I use good, *absorbent* paper towels to blot any water on my paintings, not the kind that just spreads the water or paint around. Facial tissues are great, too.

• Artificial sponges are good for scrubbing; however, natural sponges are best. You can use an artificial sponge to put down paint or to make abstract tree shapes.

• A small spray bottle is always very helpful. These can usually be found at a floral shop. Buy a small one (you don't need a gallon of water) with a nozzle that adjusts from a mist to a thin stream.

• You can use an office stapler to attach light

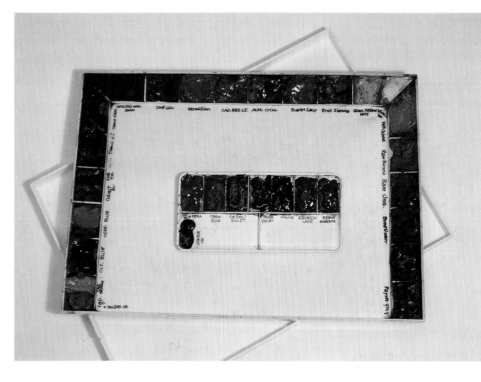

I use the John Pike palette. In my opinion it's the best one produced. The little palette in the center is one you can find in any art store for approximately $1.50. It fits right in the center of the John Pike palette, and the cover will fit over it. You might want to fill the small palette with colors you seldom use, like Opera, permanent rose or cobalt violet.

watercolor paper (140 lb.) to a board. Or use brown paper glue-backed tape. Masking tape will not hold the paper when wet, and as the drying paper shrinks, it will pull away from the tape. Metal "bulldog" clamps are also good for clamping your paper to a board. You can usually find these at an office supply store.

• To scrape or scratch out pigment on paper, I use a single-edged razor blade, a mat knife with a projector-type blade, or a good, sharp three-bladed pocket knife. Many artists use an oil painter's palette knife. You can also use a cut-up credit card, an ink eraser, or a stipple brush. The stipple brush can be used for so many things: scrubbing away a painted area, softening a tone, and even putting down a dotted stripe of tone or paint.

• A no. 2 pencil is just fine for transferring your sketch onto watercolor paper. Don't use soft sketching pencils (2B, 4B, 6B) as excess graphite on your paper will mix with the wet pigment and dull all your colors. Also, don't use hard pencils such as a 3H or harder. They will *score* your paper, and it will be impossible to erase your paper without roughing up the surface.

• To erase pencil lines, use only a soft eraser, such as a kneaded, soft gum or plastic eraser. If you use a hard eraser, you'll roughen the paper. Then when you paint the area, it will either become much darker or make your paint skip and show a light tone where you don't want it.

• People often use a toothbrush for spattering, but I prefer an oil painter's no. 6 hard-bristled fan brush. The toothbrush sends your spatter all over the place; with the fan brush, on the other hand, you can aim and control your spatter much better. Salt and turpentine can also be spattered on paper to create different tonal backgrounds.

• Masking tape can be useful in masking out large areas or shapes with straight edges. I use a 2-inch tape that can be found at a hardware store. When you press it down over your pencil lines, you can usually see them through the tape. Then you can trim it with a razor blade or craft knife and peel away the excess. Cut *very* lightly. Art masking fluid also can be used to mask out areas. Usually I use this for branches or thin lines or small areas. For big areas, I use masking tape.

EASELS

An easel is great for outdoor painting. I have two of them, one full-sized and one half-sized. The full-sized easel is fine when you travel by car. My artist friends kid me that I bring half my studio with me when I paint outdoors. The full-sized easel can carry a lot of paint tubes and brushes and pounds of other materials. But you can carry *too* much. The smaller easel is more manageable if you're going to do a lot of hiking to special areas you can't reach by car. Also, taking it forces you to reduce your equipment to just the essentials. Some tripod types of easels are also available, but these are a little wobbly when you put your board on them. If you're outdoors without an easel, just lay your board on the ground or find a convenient rock to set it on.

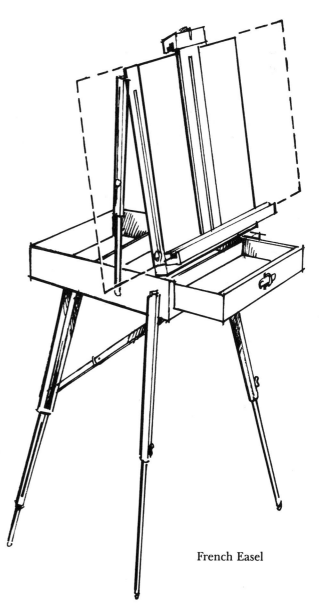

French Easel

PAINTING OUTDOORS

Working on location may be difficult, but the spontaneity that results from painting on location will show in your work and improve the quality of your painting. Being there to capture the landscape in watercolor is what you're striving for. Also, working outdoors will train you to become more observant. Don't always paint what is exactly in front of you. You can move things around, change them, subtract from or add to a scene. Just do whatever you want to do. You are the one who must make decisions based on your own feelings and aesthetic tastes.

If you have the time, paint as much as you possibly can of your scene on the spot. Our friend the sun will dictate when it is time to stop. It moves constantly, frustrating the efforts of the outdoor painter. As it moves, of course, the shadows change. Every thirty to forty minutes, a shadow that was at a certain angle will change and also change your view or some other aspect of the scene. More than one painter has returned home to find he has shadows running at two different angles in his painting.

Try to set a time limit on painting any one scene, say, about an hour to an hour and a half. Once you've reached this limit, stop (after taking sketch notes, reference photos, etc.) and move on to the next location or scene. You can finish the painting in the comfort of your studio. For one thing, the interval will give you a respite from the scene. When you get back to it, you will look at the painting with a fresh eye. This will help you see where you might make changes or adjustments.

Another way to capture a landscape quickly is to do a value sketch as soon as you arrive at the area. Take photos of the scene, then lightly draw an outline on your watercolor paper of the area you want to paint. Remember, I said *lightly*. With any luck, you will have captured the spontaneity

Here are some sketches I've done at three very different locations. Forcing yourself to translate all the beautiful colors of nature into different shades of gray is a valuable exercise that will improve your painting. I also find that a sketch is often a more useful record of a scene than a photograph. Add to that a quick color sketch with your watercolors, and you're set to go.

of the scene, but you may want to erase a line or more when you get back to your studio. The drawing done on the spot will invariably be better than one done from a too-detailed photo. The difference will show in your finished painting.

Remember also that when you paint outdoors you'll have to carry with you a good folding stool, a water container, and a mixing bucket or water holder. A heavy-duty plastic household bleach bottle is ideal. Just make sure it's thoroughly washed out.

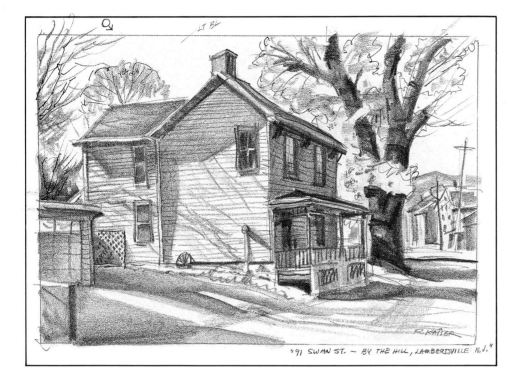

"91 SWAN ST. ~ BY THE HILL, LAMBERTSVILLE, N.J."

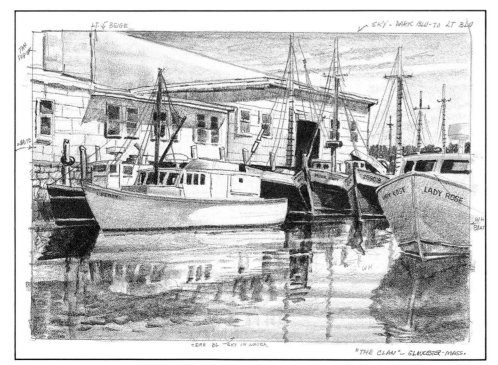

"THE CLAM" ~ GLOUCESTER ~ MASS.

DECIDING WHAT TO PAINT

Choosing a subject sounds simple to someone who's never painted. Those of us who are crazy enough to venture out with an easel, papers, brushes, and all manner of miscellaneous equipment—not to mention a jug or two of water—know better. We often experience a good deal of indecisiveness and apprehension before settling in to the day's painting location. But there are a few simple things to remember about making that important decision. This chapter will help you learn how to distill your feelings about a scene and choose a point of view that will best convey those feelings.

Paint any scene that awakens your interest—whatever stops you and makes you say to yourself, Wow! I've got to paint that! Your instinct will probably be correct. You'll devote more loving attention to a scene that hits you than a scene you really don't care about.

To capture that "wow," you have to learn a new way of seeing and directing the eye. I try to re-create in a finished painting the same response that I felt when I was at the actual location, to catch the essence of whatever made me stop to sketch or paint the scene in the first place.

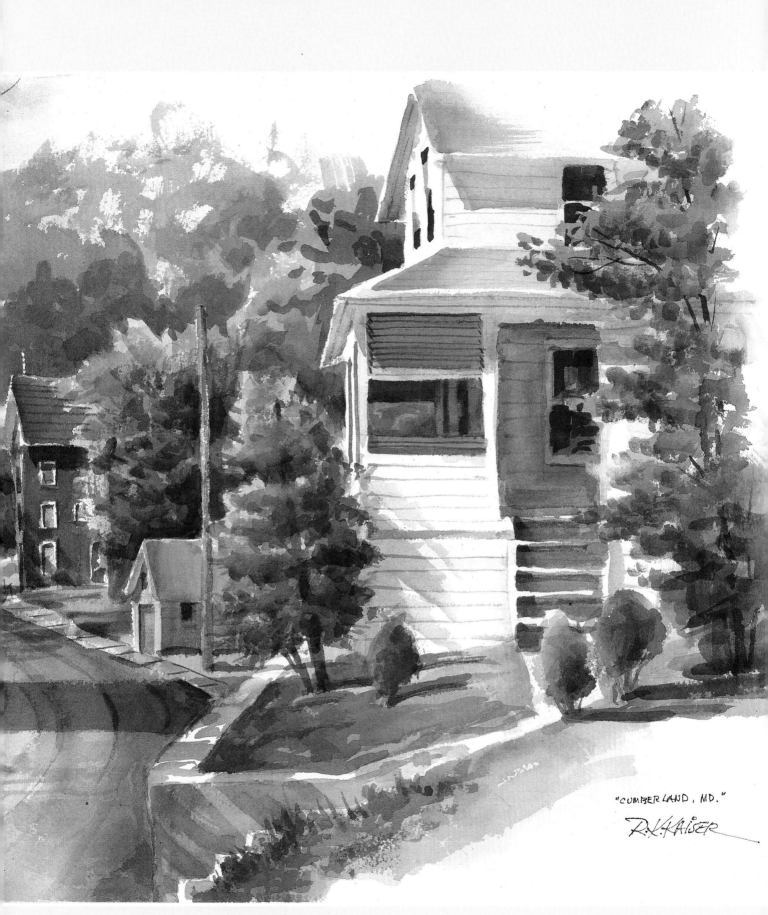

"CUMBERLAND, MD."

R.K.KAISER

CUMBERLAND, MARYLAND, 15×22″

FINDING A SCENE

People often complain, "I can't find anything to paint." In answer to that, one famous painter used to say, "Go out your front door, walk fifty paces, turn around a couple of times, sit down, open your eyes and paint the first thing you see." Whether you're in a city or in the countryside, you might be surprised if you just sat down and really *opened your eyes*. Look, really look, all around you. You'll probably find dozens of scenes to paint. The pencil sketches on these two pages were pulled right out of my sketchbook. I usually take note of the direction of the light (circle with arrow at top) and other details, especially colors. This helps me remember the scene when I'm back at my studio.

WHAT ATTRACTS YOU?

Once you've found a scene that stops you in your tracks, you still have to decide what to paint. The first rule is to *simplify*. "The great artist is the simplifier," said Henri Amiel. Ask yourself, What is the essence of this scene? Leave out any detail that is not essential to capturing the part of the subject that interests you most. Remember, your point of interest is what you—like a director in a movie—want the public to be most aware of. That's the soloist in an opera—the star of the show. The rest of the scene is made up of spear carriers or the background choir. Think of this every time you look at a scene. Where is the soloist? What is the background choir?

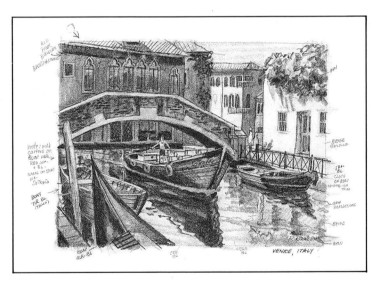

VENICE, ITALY
Venice is a great place to paint. Every five feet you see another potential painting. In this view, the water channel went around the corner and provided a very good path in and around the scene, which had a lot of overlapping features. The multicolored milk cartons in the center boat and the man silhouetted against the dark red brick building make an excellent center of interest.

NEAR FREEDOM, NEW HAMPSHIRE
The white buildings, contrasted with the red tin roofs, the yellow weeds and the grass, stopped me in my tracks. The placement of darks in the background also made the center of interest stand out. The overlapping buildings made this scene very paintable. Notice the areas that go from light to dark and dark to light in a gradated shade of values.

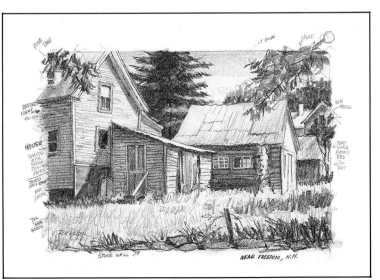

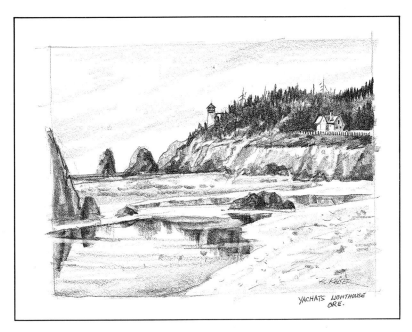

YACHATS LIGHT-HOUSE, OREGON

The coast of Oregon is a fantastic place to paint. I had a chance to look down on the lighthouse and beach and thought that was a good position for the scene. But when I went down to the beach, everything fell together. Looking up at the lighthouse made the scene more dramatic.

ME3330S, MONHEGAN ISLAND, MAINE

Another fantastic place to paint. This was right next to a lighthouse (building at left), which is the first thing you'd usually focus on. But look what interesting subject matter is right there by the base of the lighthouse! I like the oblique lines of the tools, the way they overlap and lead you to the boat and frame it. Note how I break the line of the hill with the aft end of the boat.

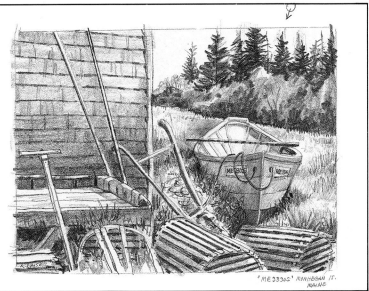

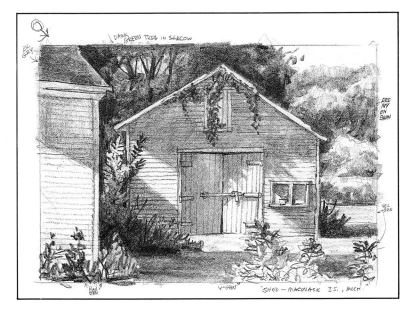

SHED, MACKINAC ISLAND, MICHIGAN

This shed caught my eye when I saw the interesting shadow pattern. The lines of the shadow and the hanging ivy help draw your attention to the door—the center of interest. The checkerboard effect of dark against light and light against dark also enhances the scene.

WALK AROUND IT

You are at the scene, and you know what you want to paint. Now, are you viewing it from the right angle? So often (and I've done this many times) we see a subject or scene and paint it, only to walk away from the scene and find to our dismay that the scene would have been better painted from a different angle.

When you arrive at your scene, walk all around it to see it from every angle. It just might suggest more than one painting. Each person sees things differently, and that's as it should be. I've often overheard people at a gallery who are familiar with the scene shown in an artist's paint-ing say, "I know that place—but I've never seen it from that angle before."

By walking around it you explore all the possi-bilities of your subject or scene.

USE A VIEWFINDER

We've all seen artists hold up their hands and make a sort of frame or box through which they look at a scene. This is a great way to isolate the area you're trying to view.

To make this viewing easier, you can make a simple viewfinder by cutting a rectangle out of a small piece of cardboard. Cut the hole to match the proportions of the paper you normally use—

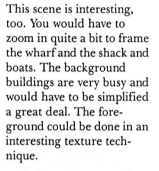

This scene is interesting, too. You would have to zoom in quite a bit to frame the wharf and the shack and boats. The background buildings are very busy and would have to be simplified a great deal. The fore-ground could be done in an interesting texture tech-nique.

This is a typical scene from the Port Clyde, Maine, area: lots of boats, lobster shacks and wharfs. This is a good scene, but the buildings are viewed straight on. The bal-ance is good, with the boats well scattered. Painted in a flat design style with hard edges, this might make a good poster-type scene.

Coming in closer to the sub-ject and viewing the shacks at a slight angle gives a bet-ter perspective to the scene. I would keep the back-ground very simple, leaving out a lot of the small build-ings. The dark trees bring the buildings forward and make your viewers notice your center of interest.

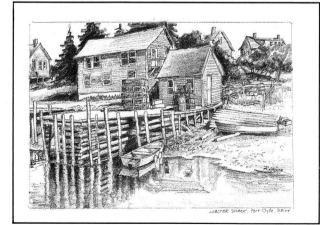

I made this pencil sketch of the scene at left to figure out the darks and lights be-fore I set brush to paper.

say, a half sheet. This viewfinder, when held in front of your eyes, helps to blot out unnecessary background features and simplifies (that word again) your scene. Also, by "tromboning"—moving your arm farther away and then back again toward your eye—you can either enlarge the view or zoom in like a camera to tighten your frame on a specific object. For instance, say you are looking at a house with your viewfinder up to your eye. By stretching your arm out, you can zoom in on just the doorway; perhaps there's a cast shadow on it and a cat sitting on the stoop. Maybe that should be the "soloist" or point of interest, instead of the whole building. It's up to

you, the artist, to make that decision. Approach your subject or scene thoughtfully, not haphazardly.

An artist friend, Tony van Hasselt, showed me a way to take this a little further. He uses a small cardboard rectangle the size of a typical business card, with two holes punched out. This card can be used to determine color and value contrast. Simply hold the card up to the scene and position it so that the two holes reveal two areas you want to compare. Because the rest of the scene is blocked out, you can easily see which area is darker or lighter or more intense in color.

Eastern Lighthouse, Gloucester, Mass.

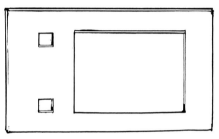

The two small holes in the viewfinder can help you compare colors and values in different areas of the scene.

Here's a scene we can use to see how the viewfinder works. Hold the viewfinder up and move it back and forth between your eyes and the scene in front of you. The big opening should be exactly the proportion of the paper you're working with. You can enclose the whole scene or just a small part of it. See page 23 for the finished painting I did of the whole scene.

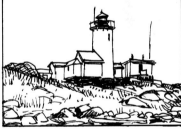

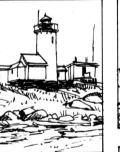

Just by moving the viewfinder around, you'll find several paintings in each scene in front of you.

ASK YOURSELF QUESTIONS

Now that you've found the scene you want to paint, stop and think for a minute before you set up your equipment. Ask yourself some important questions.

1. *What do I feel?* Is the scene one that stops you, holds your interest, and says to you, "Paint me"? Does the scene inspire in you an emotion that will carry over to other people? What is it?

2. *What do I see?* Can this scene become a good painting? Are there enough objects to make it interesting? Too many? Will other people be able to relate to it? Does it have all the visual information you want it to?

3. *What do I want to express?* Will you have to add to or delete anything from the scene in front of you to express your point of view? Remember, it's your *interpretation* that will make the painting. Don't just copy—create the scene.

4. *Are there good lights and darks?* Are they balanced and spaced properly? There should be pleasing intervals between the light and dark passages, such as a light silhouette against a dark form, or a dark shape against a light form. This contrast in value will help identify an object such as a white house against a dark mass of trees.

5. *Are there good shapes in different sizes? Do they overlap?* Is there a large simple shape that could hold the painting together? A few big shapes will usually make a better painting than a lot of tiny shapes. But it's also interesting to have shapes of varied sizes. Overlapping can help tie a scene together, too.

6. *Is there one good point of interest?* Keep one—and only one—point of interest. Very often we will find several points of interest in a scene. Choose whichever you think would make a good one, then downplay the rest. Also, place your point of interest off-center so that it doesn't become a bull's-eye painting.

It was a quiet morning in this very pretty area in North Carolina. A few trucks had come in to pick up loads of grain. I wanted to show the morning sunlight playing over the buildings, trucks and trees. Of the several photos I took, this was the best. Notice how the shadow patterns lead you to the subject matter. The darks on the right are balanced by the sunlit shed on the left.

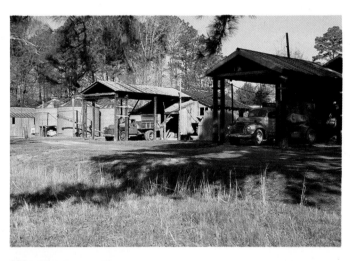

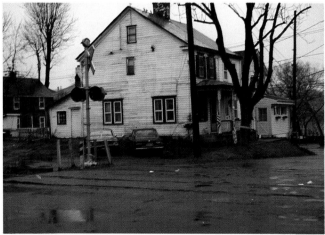

One rainy day I was roaming around the town of Lambertville, a small, picturesque town by the Delaware River. I had seen this house many times before. But this time I was stopped by the reflections on the wet street and the tracks of the railroad running through it. There were just enough puddles and reflections to make it interesting. The dark tone of the wet street against the white clapboard house also caught my eye.

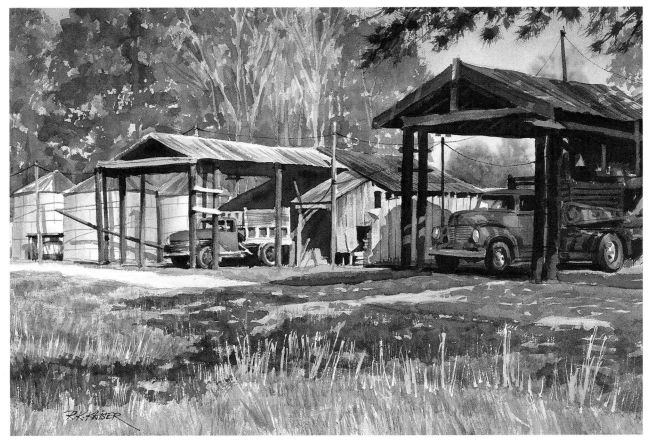

GRAIN DISPENSING WAREHOUSES, ORIENTAL, NORTH CAROLINA

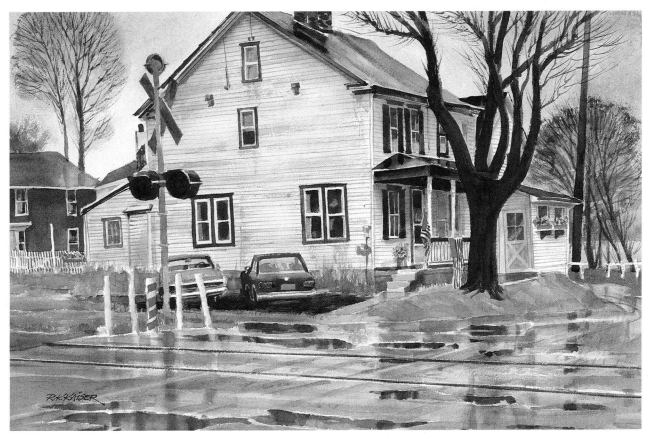

HOUSE BY THE TRACKS, LAMBERTVILLE, NEW JERSEY

PUT YOUR IDEAS ON PAPER

Once you've found a scene, walked around it, checked it out with your viewfinder, and found answers to the preceding questions, it's time to put your ideas on paper, either by sketching or by using your camera. Sometimes seeing the whole scene in all its surroundings is fine. Just for fun, zoom in to just one small part of the scene. (This is where a small viewfinder works great.) Does this produce a better picture, a better composition? Does it come closer to expressing what you wanted to say in your painting? Instead of the whole barn, how about using just that part of the doorway that's open and gives a glimpse of the hay rake inside? Make several quick sketches to visualize these views as paintings. A 35mm camera equipped with an inexpensive zoom lens will allow you to do this quickly and easily. I have one now and wish I'd bought one years ago. It has made possible many different ways to view a scene for a painting. For instance, instead of walking across a field to see a barn close up, I now let the camera do the walking for me.

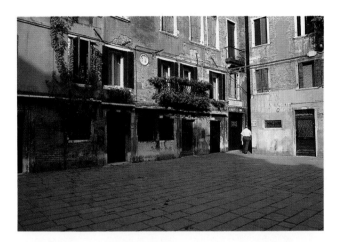

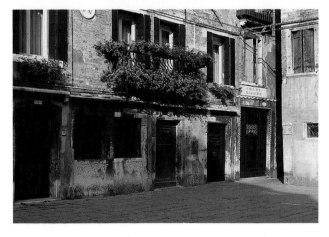

I think this shot is the best of the three. It shows the textures, the detail on the doors, and the flowers by the window very clearly. The shadow pattern will help me work out the composition. It points you to the right, where I added the figure of a lady carrying a bag.

(Left) Here is one of the many streets and court-yards in Venice. I was attracted to the interesting shadows and textures.

(Below) In this closer view, the shadow pattern is still good and it's somewhat simplified. The flowers and the doorways are becoming more important.

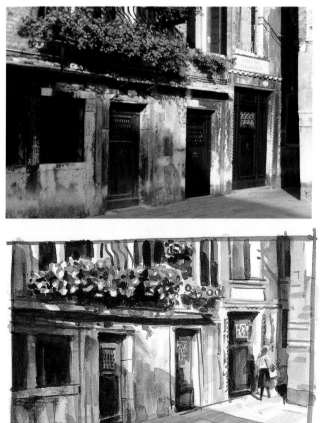

Here is the small black-and-white wash sketch I did to capture the shadow patterns and to figure out medium and light tones.

CHOOSE THE BEST

Sometimes when we go out to paint we are just going through the motions, trying to cover our paper with paint. But that's not enough—we have to be excited. If we aren't, then the viewer looking at the painting won't be either.

When choosing the best scene to paint, remember: Simpler is better. Paint the scene that strikes you first, but apply every skill you have to make that scene better. Don't paint the scene exactly as it appears. People can see that for themselves. You want to help others see the scene through *your* eyes.

Although you try your best, you won't always succeed in capturing a subject. There will always be some paintings that, long after you've sold them, you'll wish you could change. Don't try to paint for the public, just paint for yourself. Try to paint a part of yourself in every painting: "Here's the view I like; here's my rendition of it. Here's part of me."

"All great art is the expression of man's delight in God's work, not in his own."

—John Ruskin

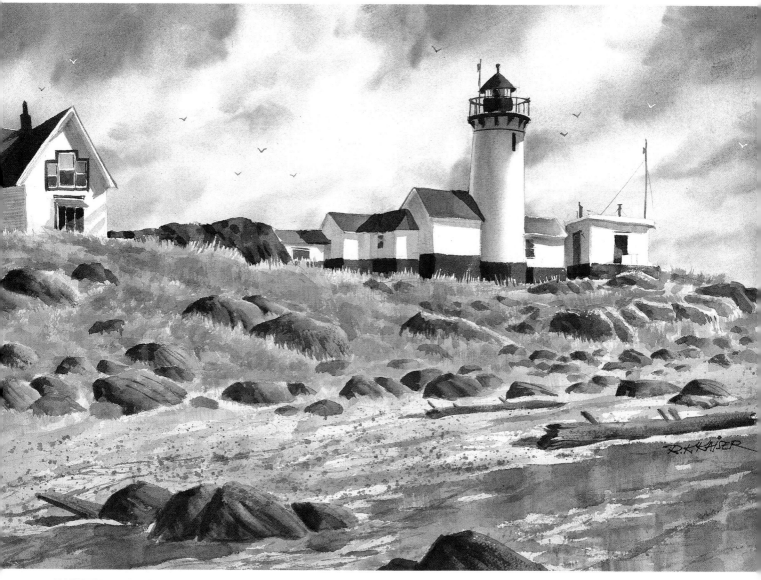

EASTERN LIGHTHOUSE, GLOUCESTER, MASSACHUSETTS, 15 × 22"

CHAPTER THREE

DESIGNING A SUCCESSFUL PAINTING

Composition is a process of making a series of decisions by which we hope to establish order. To do this we arrange shapes (or forms) and tonal values (light and dark) in pleasing relationships.

Many beginning landscape painters are stymied by the vast, open-ended scene they see before them. They have no idea how to put what they see into a pleasing order or composition. But you don't have to start from scratch. There are plenty of "tools"—principles already proven—to help you get started: weight or balance of shapes; the center interest; points of direction; entrances and exits; natural designs (rocks, trees, mountains, water); and inanimate shapes. The way you use these "tools" makes up your personal approach to composition.

Remember, you are the "builder" of the scene. You don't have to use your subject as is. To quote Zygmund Jankowski, "Twist it, break it, bend it or throw it away. Find out what you have to say." It's up to you to rearrange the elements so the viewer's eye sees what caught *your* eye in the first place.

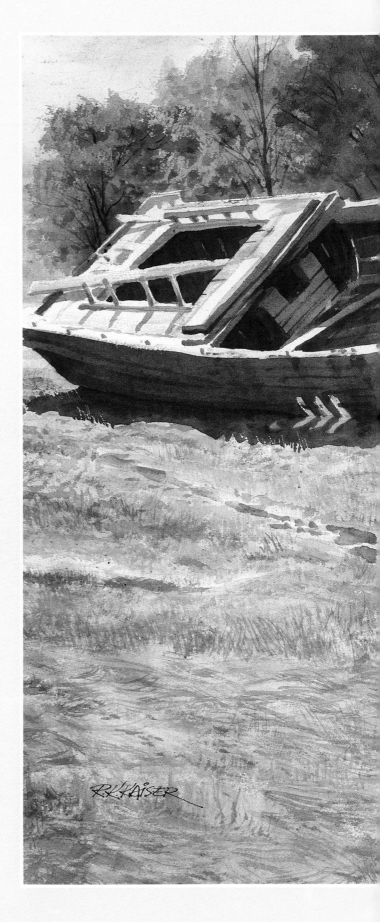

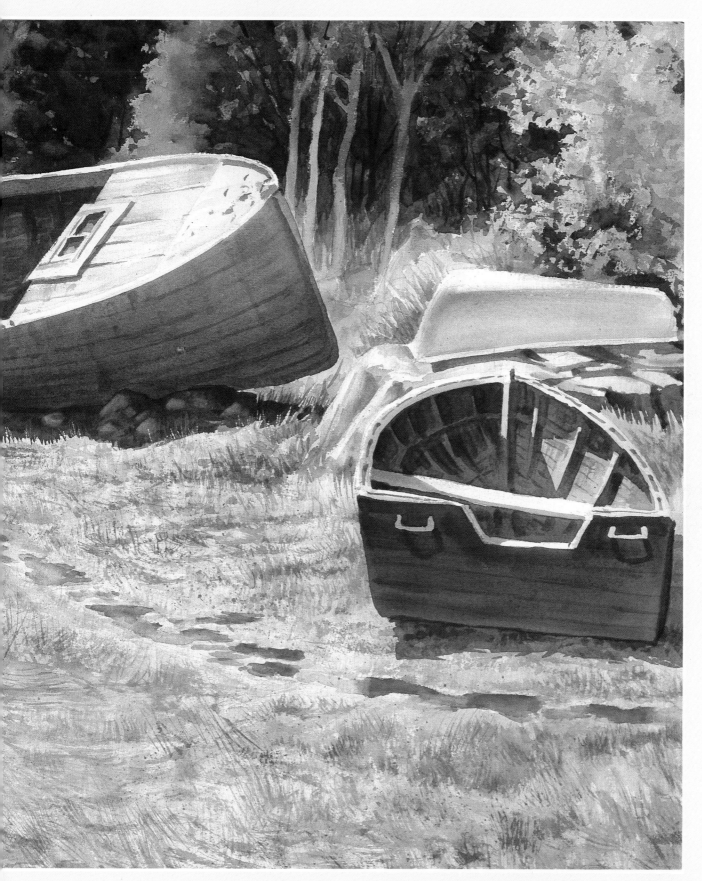

OLD GRAY #2, ROCKPORT, MASSACHUSETTS, 22×30"

ARRANGING SHAPES

There are many ways to arrange shapes in your painting. Your choice of arrangement is based on a number of things, including the subject itself and the mood you want to convey. Shape is the strongest single element. As Edgar Whitney often said, "We are shapemakers."

VARIETY IS MORE INTERESTING

We often fall into "traps": painting mountains the same height; spacing trees evenly like fence posts; making all the rocks the same size. Varying the height and apparent size of trees, buildings or other objects will prevent boring repetition and generate much more visual excitement in your painting. Also, throwing things a little off-balance makes any painting more interesting. That little touch will make a viewer really stop and look.

POSITIVE SHAPES

Barns, houses, major trees, rocks, boats—all of these are subjects we love to emphasize. These are usually your points of interest, the things you want everybody to look at, the things you want to stand out. These are called *positive* shapes.

The variety of pleasing points of interest can include areas of white or dark. To be dominant, one will usually have to be larger than the other. Keeping the tonal value of your positive shapes simple will make them stand out too.

These mountains are all the same height and very boring.

Just a small variation in height makes them much more interesting.

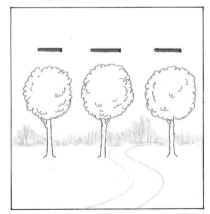

When all the trees are the same size, again, it's boring and does not make a good composition.

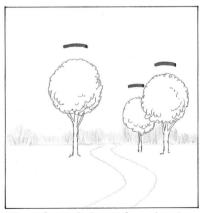

Here, size variation and overlapping make a big improvement.

MIKLOUS FARM, ILLINOIS
The irregular half-circle of the top of the barn is an obvious positive shape, as is the light blue parallelogram of the roof. The inverted orange triangle of leaves between the roof and silo is a negative shape.

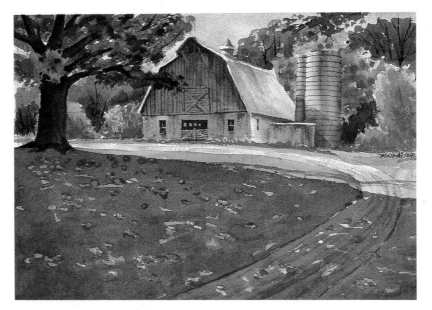

Here is a light area silhouetted against a dark. The white farm buildings are a positive shape, while the dark trees form a negative shape behind.

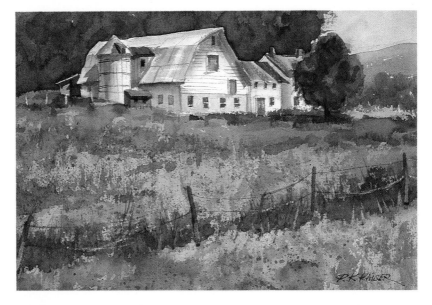

This big silo dominates the picture, commanding attention. The big shapes are broken up a little by the stones and shadow pattern and by the mountains and shrubs to the right.

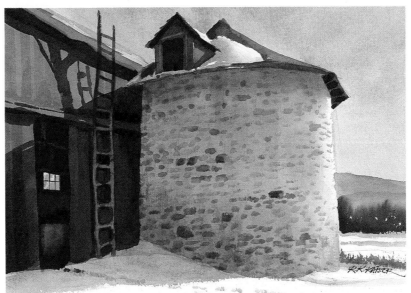

NEGATIVE SPACES

Negative shapes could include air, sky, water, trees, maybe even sand or grass—anything that makes up the space around the positive shapes. Areas of dark or light can be either negative or positive, depending on how they are used. If one area has a dark or gray background, an adjacent area that is left white will stand out and be a positive shape—for instance, a white barn against dark green trees. But if a large area is left white, it usually becomes a negative shape.

OVERLAPPING

Overlapping is one of the easiest ways to produce a better painting. Overlapping objects (buildings, rocks, trees, whatever) instead of scattering them all over your painting instantly makes them more organized and interesting. Overlapping can tie a whole scene together or shift a picture left to right, up and down. It can show perspective, and always helps to define the relative size or height of objects in a scene. Above all, it's the best way to avoid making a boring painting.

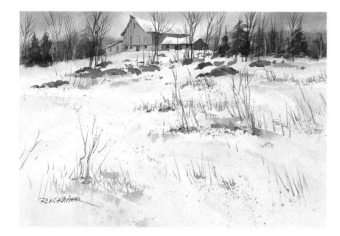

(Left) A big negative area of snow is set off by a dark area of positive shapes at the top. The high horizon line makes this scene interesting even though three-quarters of the painting is negative space.

(Below) This is just the opposite of the negative snow scene. The horizon line is much lower, with the darkest area at the bottom, offset by the light sky.

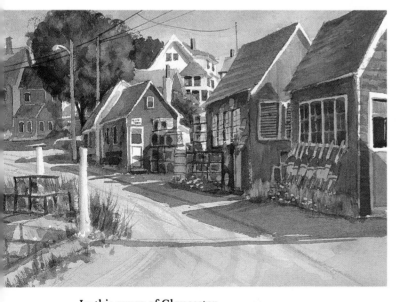

In this scene of Gloucester, Massachusetts, the overlapped lobster shacks and trees and the small details of local color help show perspective and distance.

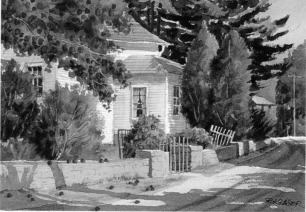

In this painting, the trees that overlap each other and the house, plus the building in the distance around the curve all combine to create a sense of depth.

SILHOUETTES

In arranging shapes for your painting, be aware of the silhouette shapes that stand out in your scene and help define the forms of your objects. As "shapemakers," we must keep our shapes simple. Breaking the edge of a silhouette can be interesting, as long as it doesn't make the shape confusing. If you break the silhouette too much you may lose it completely. Silhouettes are a great help in composition. They make your painting instantly understandable.

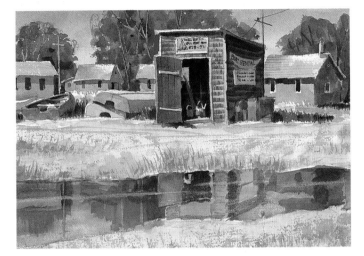

The boat rental building, the boats, and the buildings in the background, though modeled with color, are silhouetted against the dark trees. The silhouette shapes help to show the forms of the boats and buildings in the background. The telephone pole and tree outline describes what they are. Notice how the darks in the background outline the buildings, chimneys and roofs to clarify what we are looking at.

The lighthouse as well as the trees are silhouetted against the light sky—dark against light—making a clear, dramatic reading of form.

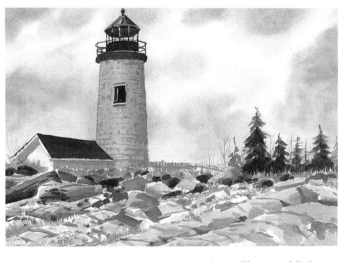

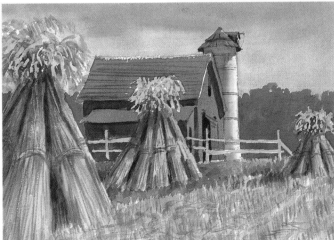

Again, I silhouetted light shapes against dark backgrounds. Simple trees in the background outline the stalks and fences. I darkened the barn to show off the middle wheat stalks.

VIGNETTES

Vignettes are one of the simplest ways to solve your problems with a scene. Let's face it; sometimes it's difficult to get interested in a scene. You might do a preliminary black-and-white value sketch or small pencil sketch and find it still doesn't seem to gel. A vignette—a picture with an irregular shape without square edges to frame it—just might be the solution.

Although you won't cover your entire paint-ing surface, you should touch all sides of your painting with color. But counterbalance the edges you touch. In other words, don't touch two sides directly opposite each other. Use areas of white to allow the viewer to enter into the scene, but don't leave so much white space that it becomes overpowering and too important. On the other hand, too little white space will destroy the vignette shape.

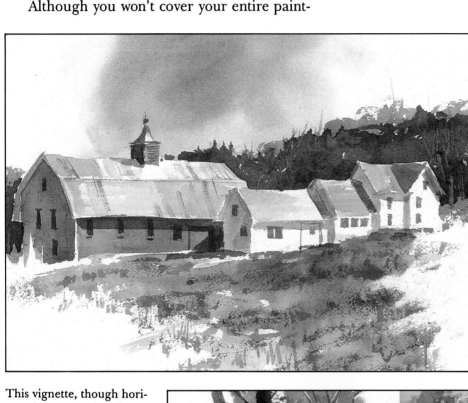

In vignettes, it's important to touch the sides of the paper, but not directly opposite each other. Notice how the blue sky area is touching the top edge a little left of where the green ground mass touches the bottom edge. The green trees on the left touch the edge just about midway, and the trees on the right are slightly higher. The whites of the background form a pattern of different shapes. A white area leads in from the left and directs your eye toward the houses.

This vignette, though horizontal, has a vertical thrust. I used more of a drybrush technique to produce sharper edges, which made the white areas more apparent.

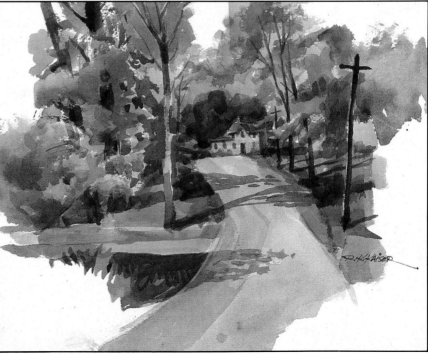

ENTRANCES AND EXITS

When you stop to look at a painting, how do you view it? First of all, the fact that you've stopped means the painting has caught your attention. Now, can you enter the painting, walk around in it, and come out visually satisfied? It sounds strange, but think about it. If, when viewing a painting, you have to fight your way through visual barriers to get to the point of interest, the painting's composition has been poorly planned. Visual barriers can be a big hindrance to the enjoyment of any painting. The composition should have "entrances" and "exits" that allow you to get into the painting, explore it and then get out. Vertical lines, such as fences, trees, and so on, placed on the sides or in the foreground stop your eye. You can't visually jump the barrier to get at the point of interest. By breaking these lines you create an entrance into the middle of the painting, allowing viewers to gain access to what you intended for them to see. By the same token, now that you have their interest, your composition should let them explore and then give them a way out of the scene—an exit.

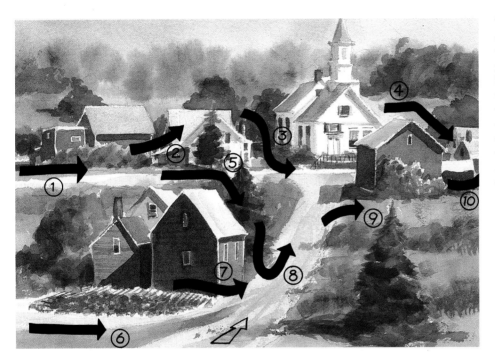

This scene in Vermont is quite a simple painting, but well thought out. Your first inclination would probably be to enter the scene from the dirt road at bottom center and travel immediately up to the white church. But you can also enter the scene visually from points 1 and 6 at the left. Points 2 and 3 let you explore the center of the painting. Points 7, 8 and 9 let you roam around some more. You can exit the scene at the right from points 4 to 10 or from 9 to 10.

Again, you would likely enter this scene first from the snow-covered area in front of the barn. But this snow scene can also be entered from points 1 and 3—point 1 coming in from the hill curving to point 2 and encompassing the barn, then on to point 6, then up the hill and out, or out through point 7. Another entrance is from point 4, moving along to where the barn roof breaks the mountains at point 5, then on to points 6 and 7.

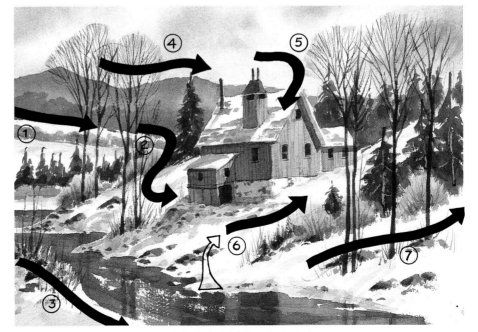

ARRANGING VALUES

The best way to go about arranging values is to do a value sketch. The value sketch is not meant to be a finished painting. It is a quick sketch that helps you see your subject in its simplest form. Detail in the scene in front of you should only be roughed in or suggested. Here you are more concerned with light tones, middle darks and the darkest darks.

If you keep your value sketch small, it will be quicker and easier to compose. Starting on a large sheet will tempt you to keep adding things that are not essential. If I seem to harp on keeping things simple and "less is best," it's because this is important. In fact, I have to keep reminding myself of this when I'm out in the field. We all have a tendency to see too much in front of us.

Values are one of the most important building blocks in painting a scene. We use them to establish depth in a painting. Values make you aware of the far distance and the middle ground; they also push the foreground up to the front, and are a way to create entrances and exits. Remember, you're working on flat, white paper; using correct values will give you a third dimension. Values help the various shapes in your painting make sense, showing where the shapes stand and making them tell the story you want them to tell.

SKETCH WITH THREE VALUES

You can make your own gradated value chart with markers or buy one at a photo store that already has the values numbered from 1 to 10.

All you really need to do a quick sketch are three values—light, medium and dark. When viewing a scene or area you want to paint, look for the middle tone first. Establish it with a single stroke, just so you can see it. Now pick the lightest area and establish that. Then double-check that these are correct and in proper relationship with each other. Next, determine your black or dark-

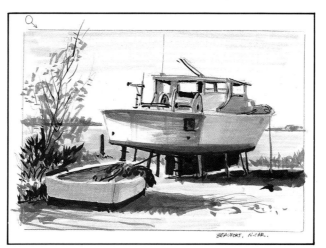

With these three simple values—light, medium and dark—you can simplify your drawings and sketches, as I did in this marker drawing. I established my medium tone first, then my lights and darks.

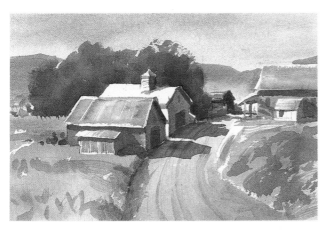

Notice the three simple values in this small watercolor. The soft, middle value of the mountains suggests that they are far away. The dark trees push the light buildings to the foreground and silhouette them. The dark cast shadows say the scene is in bright sunlight.

After you have learned to simplify to three values, you can expand to as many as eight value tones. You will still need to simplify a lot to render your scene in eight tones. I find it best to limit myself to five value tones.

est value. When you are finished, all of the values should correspond to the scene in front of you. The rest of the intermediate tones, while important, only assist the three main values.

CREATE THE ILLUSION OF REALITY

The values in your painting tell a story. How distant are the mountains in the background? How close is middle ground? How near is the foreground? Study the way large groups of trees form large dark-value masses. Those surrounding a light subject make the subject stand out. They also may be used to indicate sunlight falling on a subject.

An object painted with one tone looks flat and one-dimensional. Give it more than one value and it becomes a solid, three-dimensional object. A gradated value from one side of an object to the other gives a feeling of roundness.

TARGET THE CENTER OF INTEREST

Surrounding your subject or point of interest with carefully handled contrasting tones is a great way to call attention to it. For example, a dark

mass of trees surrounding a light-valued subject (house, barn, bridge, etc.) will give the subject great importance. But even when silhouetting a subject, values can be quite varied within a general value range. They can be differentiated with lots of color in the foreground and lead to a more solid mass in the background. Even light tones like those of mottled grass can lead your eye to a background value mass.

SAVE YOUR WHITES

I always tell my students, "Leave more whites than you need." You can always paint over them or tone them down. However, putting them back into your painting, although not impossible, will take a tremendous amount of work.

Whites provide the "sparkle" in a painting. When you paint a solid area, such as the roof on a barn, don't completely fill it up with paint. Leave a tiny sliver of white along the edges. Step back and you'll see how that spark of white enhances the roof. Whites in a painting are like frosting on a cake, the final touch that brings everything together.

In this watercolor sketch, I've surrounded the light values of the cabin with the darkest values, which helps to "target" the cabin as the center of interest. The lines of the walkway also lead your eye to the cabin.

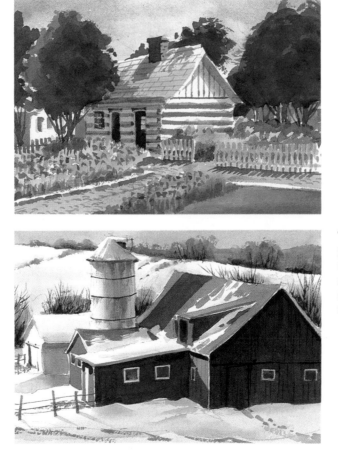

To save your whites, you've got to plan ahead. I've left quite a bit of white in this snow scene. Soft shadows and light-to-dark areas help make this scene work.

PUTTING IT ALL TOGETHER

The preliminary black-and-white sketch is an important building block for planning your painting. "When you fail to plan, you plan to fail," as my friend Tony van Hasselt often says. You *must* plan before you start your watercolor.

Let's say you've arrived at the scene and decided from what angle you want to paint. Now is the time to take out your sketchbook and pencils or markers and sketch in your values and shapes. Capture the sunlight on the subject and its cast shadow, or if it's a gray day, balance the light and dark tones. Explore the composition in front of you. Take your sketch, move things around, erase them, change them, do anything you can to make it better. Sketching like this gets your creative juices flowing. Sketch any way you like—fast, detailed, loose, tight, dark, light, whichever way will help you plan your painting. Depending on the scene in front of me, I may do a contour drawing or a quick sketch that picks up just the major points or, if I have time, a more detailed drawing.

CONTOUR DRAWING

Contour drawing is one of the quickest and most personal ways to put line on paper. Just put your pencil on the paper and move it around. Don't lift it off the paper; keep it moving while you look at the subject before you and then back to the paper. Think of your pencil as actually touching the objects in the scene. If things overlap, fine. Keeping a very simple outline of the subject will provide you with a "pure" outlook of the subject. However, its very simplicity makes it quite difficult. In contour drawing, you attach the subject to the background shapes. You only suggest forms and shapes—don't draw every bush, rock or tree—leaving empty spaces within the lines of your drawing.

QUICK SKETCHES

Quick sketches are the best way to draw when you do outdoor painting. Because the sun is constantly moving, you don't have time to capture much more than the direction of the sun, the subject and the cast shadows. Just get the details you need for the painting—the most important aspects of the scene in front of you. In the three quick sketches shown at right, I concentrated on the direction of the light, the major shapes and values, and the cast shadows.

I felt a contour drawing would be the best way to capture the rhythmic motion of the winding road and overlapping houses in this scene.

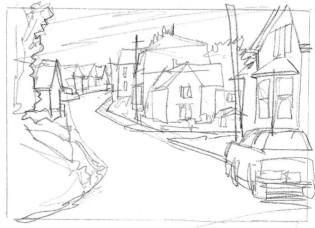

I tried to keep the pencil moving in a simple rhythmic way along the outlines of the road and houses.

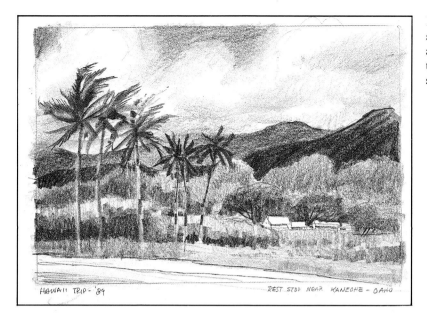

I sketched this Hawaiian scene from a rest stop along a road in Oahu. Although the sketch is quite simple, it still shows a lot of the area.

On a trip through Holland I did some sketches from my bus, working quickly to capture the light, shadows, values and large shapes.

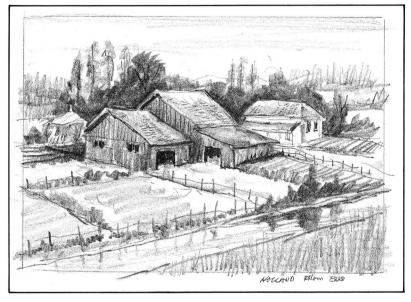

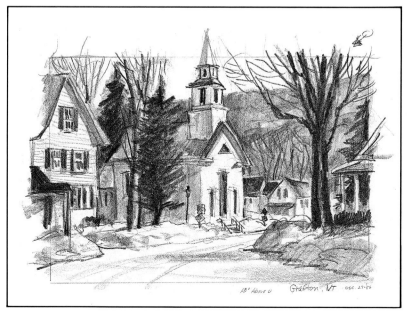

This picturesque town of Grafton, Vermont, is a great place to paint. I parked on the side of the road and used my car hood for a table, sketching very quickly—it was about 13 degrees above zero.

DETAIL DRAWINGS

These are not exactly the opposite of quick sketches, but they're a way to remind yourself of the local character or flavor of a scene. Local character includes the variety of details that add interest to the scene or subject—the big oil drum on its side, the pile of lumber, the small "For Rent" sign on the side of the building, the crumbling stucco, the iron railing, cobblestones, a leaning broom on the porch or a shovel in the barn, or a hanging harness—little things that make up the mood or feeling, the time or place of the scene in front of you. You can do a detailed drawing and then later, at your convenience, leave out what you don't think will give you the flavor you want. Jot down some notes in your sketchbook or even in the border of your sketch, because when you walk away from the scene, you may never get back to it. Make notes of the colors of objects you draw to jog your memory later.

OUTDOOR VS. INDOOR DRAWING

When sketching outdoors, we have to be aware of time. The sun moves constantly, and so do the shadows. We have to sketch as quickly as possible but still get as many of the particulars as we can to capture the flavor or mood of the scene. Leaving the scene without at least a quick sketch and trying to paint it from memory in your studio later (unless you have a photographic memory) just won't do. You'll forget many important parts of the scene or subject.

On the other hand, indoor drawing—where the light is constant, the temperature is under

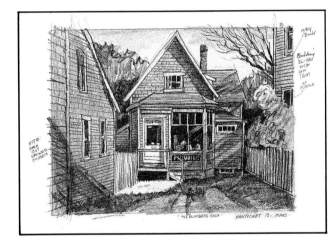

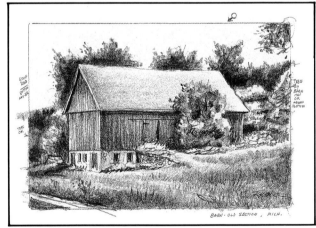

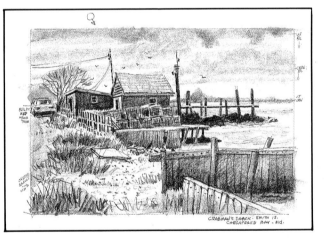

(Left) This plumber's shop is one of the great houses on Nantucket Island, with interesting shapes and shadow patterns. I included enough architectural detail to allow an accurate rendering in watercolor.

(Left) There are barns in every state, some more interesting than others. This barn is simple, but it was surrounded by beautiful fall colors. I jotted down notes in the margin to help me remember the colors later.

(Above) This crabman's shack on Chesapeake Bay had so many interesting things around it that I put everything in. I'll simplify it considerably when I do the watercolor, choosing the details I like best.

your control, and there are no bugs or disrupting factors—is ideal for a lot of people and is the only way they want to work.

However, I don't believe you can truly capture the feeling of a landscape working only in your studio—unless perhaps you have many years of on-location painting experience. But we can compromise. Sketch outdoors, and then bring your sketches home to your studio or work area. In the convenience of home you can move that tree, shift that barn, overlap a couple of boats, enlarge that boulder, widen that small part of the stream. Remember, you're the artist. You decide what you want to do and what to put before your viewing public. The painting is the final product of your artistic ability.

Sketching outdoors and using my car hood as an easel, I tried to capture the intricate shadow pattern on this old building.

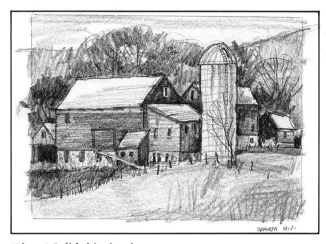

(Above) I did this sketch while on a painting workshop in Sparta, New Jersey. The lighting on this interesting complex of barns and buildings was diffused on that gray, threatening day.

I did this pencil sketch in my studio from reference photos. This house in Old Salem, North Carolina, was a great subject. Of course, the fence made it doubly interesting.

MINIWATERCOLORS

One summer long ago, when I was painting with John Pike, I was in the throes of working on a painting that was not progressing very well. John heard me grumbling to myself and asked what the problem was. "I should have done this part and that background and trees differently," I replied. "Now I'm having problems trying to fix and save the painting." John grinned and said, "Well, you've seen my miniature watercolors. Now you know why I do them when I'm going to do a big and important watercolor." He had shown me many of his beautiful small paintings (5 × 7-inch and other small sizes), and of course,

91 SWAN STREET, LAMBERTVILLE, NEW JERSEY
The bright yellow foliage not only silhouettes the dark lines of the roof but also reflects a lot of color into the shadows on the building's face.

OLD BARNS
This miniwatercolor captures the roughness of the buildings. There are a lot of textures, and the shadow pattern is also quite good. A building out of view on the left has cast its shadow on the sheds. You don't have to see the building to know it's there.

I thought they were fine, but I was not "into minis." Then he said something else that struck home. "You see, I make all my mistakes and figure out all my problems on the small ones, then I go on to the big sheet. Now I know where I'll be having problems or trouble in the big one, and I've figured it all out. Why waste a big sheet of watercolor paper? Make your mistakes on the small one." Makes sense, doesn't it?

Besides solving your problems, miniwatercolors are fun to paint, and they make great gifts. They're also done by a surprising number of very famous artists.

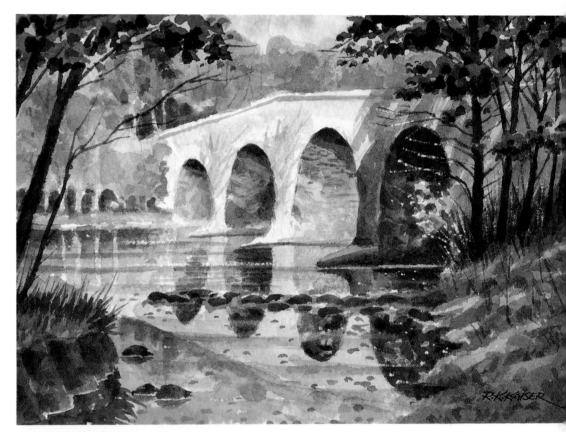

BRIDGE, KINGSTON, NEW JERSEY
Besides the historic bridge there is also a mill dating to the 1700s to the left, outside the picture. The problems I wanted to solve in this mini concerned the reflections and how to relate them and the other details to the main subject, the bridge.

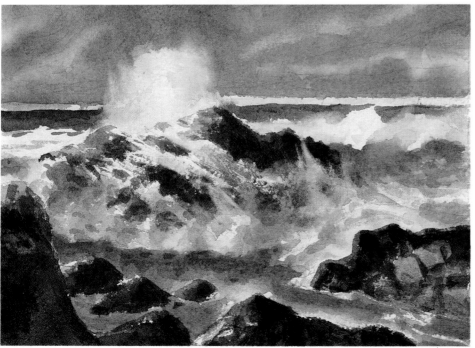

BASS ROCKS, ROCK-PORT, MASSACHUSETTS
Seascapes are fun to do, but as in everything else, you've got to plan ahead. There are reflections in the water and also in the rocks. I had to save my whites in many different areas, including the edges of the boulders and along the horizon line.

USING PHOTOS

Most painters use a camera in their work. If you don't already have one, get yourself a good 35mm single-lens reflex camera. Most 35mm reflex cameras have a 50mm lens. I use a 50mm and a 28-70mm macro zoom lens. The 28-70mm macro lets you focus close up and also zoom in on things that are far away. Let's face it; it's much easier to zoom in on the doorway of a distant barn than walk across the field to get there. You can also use the 28-70mm lens to photograph your finished paintings.

One of the big problems with the camera is that it sees everything. As Zygmund Jankowski has said, "You can't compete with a camera. The camera sees everything and nothing; whereas you see everything—and it's up to you to make some part special." Use the camera as a "memory booster." Use it to record the local color and the slant of the shadows when you first arrive at the scene. Your photos will be a great help to you when you get back to the studio.

A scene can be intimidating because there's so much to see. When that happens to you, take a "panorama" shot. Focus your lens on the far right and shoot; then move the camera a little to the left, overlapping part of the first shot, and shoot again. Now move it one more time to the left, incorporating part of the second frame, and shoot. Now you have three photos of the scene in a mural-like sequence. When your photos are developed, put them side by side, line up the elements in the scene, and tape them together on the back. Now you can see everything that was in front of you when you were on location. Occasionally I spot another painting in the scene that I really wasn't aware of when I shot the photos.

Be aware, however, that it's easy for photographs to become a "crutch." When you rely on photos too much, your paintings tend to become stiff. Also, don't develop the bad habit of copying everything that's in a photo. Use your creativity and imagination to move things around if you need or want to. Move that tree, rock or barn if it would be just the right thing to make a better composition or to give that finishing touch to your painting.

In this snow scene I liked the shadow patterns, and the composition was interesting. Try to compose your scene in your camera's viewfinder.

This rural scene caught my eye, so I took several shots walking up the road and then back. The center of interest (the house), the road leading up to it, the color, plus the puddle of water really made the scene.

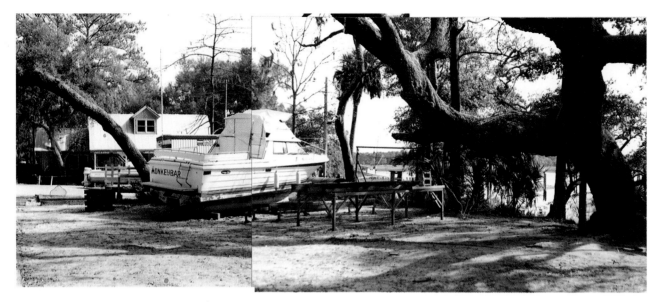

This photo is a "panorama" of the boatyard at Hilton Head Island. I focused first on the huge old tree on the right, getting just part of the boat in the shot. Then I got the rest of the boat in the second shot, along with the building and trees in the background. There's a lot of subject matter to choose from in this scene.

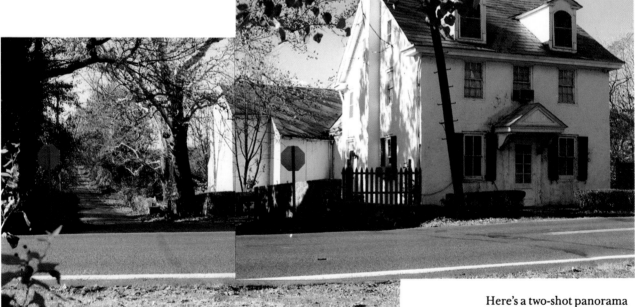

Here's a two-shot panorama of a farm scene in the historic Washington's Crossing, Pennsylvania, area. The house and barn and the shadows cast on them were captured in the right-hand photo, while the trees and country lane were shot in the left-hand photo. Combined, they'll make a great composition.

STEP-BY-STEP DEMONSTRATION

I photographed this house in Lanesville, just outside Rockport, Massachusetts, to use for a watercolor. The photo turned out fine— good color, composition, light and cast shadows. Some cropping will be necessary, of course.

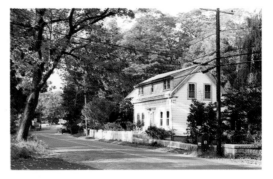

Here's how I decided to crop the photo to get a better arrangement of shapes.

Then I did a quick marker sketch to get down the light and dark values, but this can be changed. Do more than one if necessary, adding things or moving them around. This is a very important planning stage.

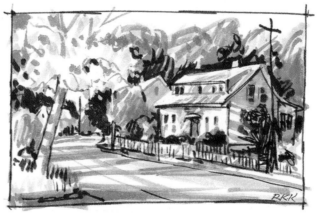

This is a more detailed pencil sketch of the same scene. I made some changes and added a few things. Because I wanted the house to be the center of interest, I arranged my shapes and values accordingly. I was careful to save my whites, especially on the house, which will be framed by dark foliage to make it stand out. The shadows on the road, the tree and the telephone pole also frame the house in an interesting trapezoid shape.

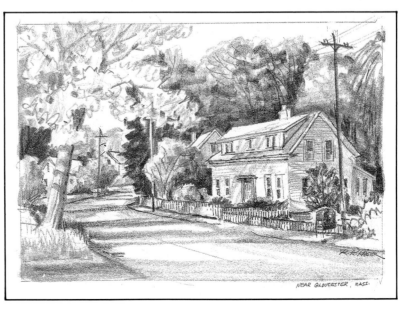

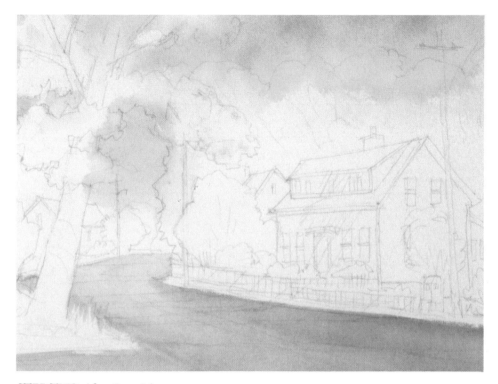

STEP ONE. After outlining the scene in pencil, I can proceed with the first washes. I want to retain the yellow foliage of the tree to the left, so I have to paint around that space. I paint the sky using ultramarine blue with touches of cerulean blue. I bring the wash down past the tree level and fade it off to nothing with clear water. Then I paint around the areas of the yellow tree on the left. I mix a wash of ultramarine blue and burnt sienna (to make a gray) and flow it in on the roadway.

STEP TWO. After Step 1 is dry, I flow in the yellow in the tree areas, on the ground and in the background trees. Notice how the roundish yellow shapes of varied sizes are balanced throughout the painting and add variety to the linear shapes of the house, tree and pole. I mix a light medium wash of Hooker's green dark and raw sienna and paint in the greens behind the house and along the fence and background curve of the road.

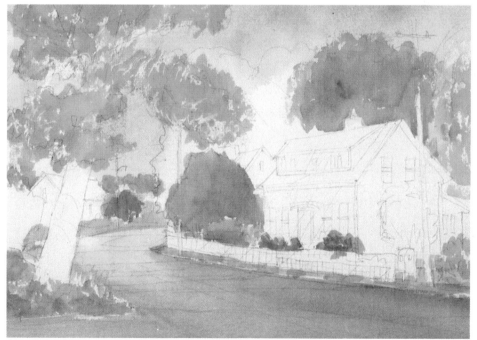

STEP THREE. Now I can really start to add some depth to the painting. At this stage I have to be extra careful to save those whites. Mixing ultramarine blue and burnt sienna, I make a light wash for the shadows on the house and a darker one for the cast shadows in the road. I indicate where the shadows hit the house and fence coming from left to right. Always make sure your shadows come from a consistent light source. To add warmth to the shadows, I flow a light yellow ochre and alizarin crimson into the house shadow wash while it's still wet. This must be done while wet for the colors to blend into the blue shadows.

Now I flow in the dark green that will frame the light house, using Hooker's green dark and adding cadmium red light to darken it further, with just a touch of phthalo green. I add the dark to other trees and bushes on the right-hand side (the sun is coming from the left) to give them form and shape. I also paint a wash of phthalo blue for the mailbox on the corner.

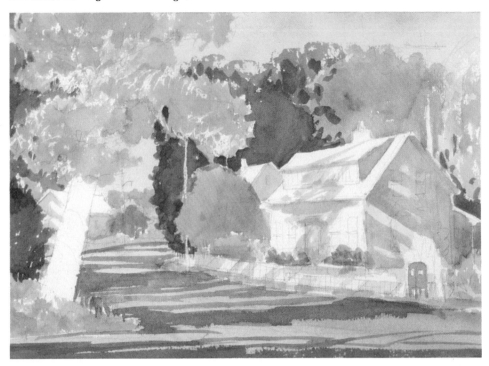

STEP FOUR. Now I add the roof color to the houses with a gray made up again of ultramarine blue and burnt sienna. This is still a lighter value than the trees behind the house. I add a light wash of cadmium red light for the chimneys. I punch the greens a little darker around the house and form them more with the colors mentioned in Step 3. When the washes of the cast shadows are dry, I add the dark green tree on the side of the house. I leave the telephone pole and tree trunk white—I'll add the colors to them later.

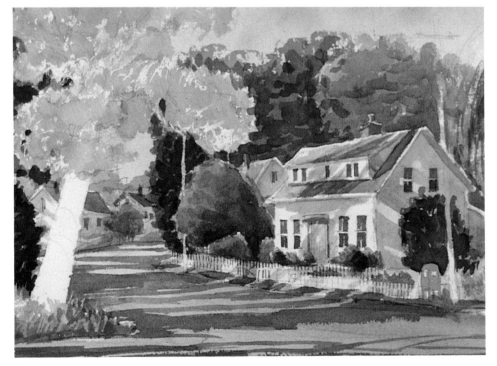

PAINTING OUTDOOR SCENES IN WATERCOLOR

44

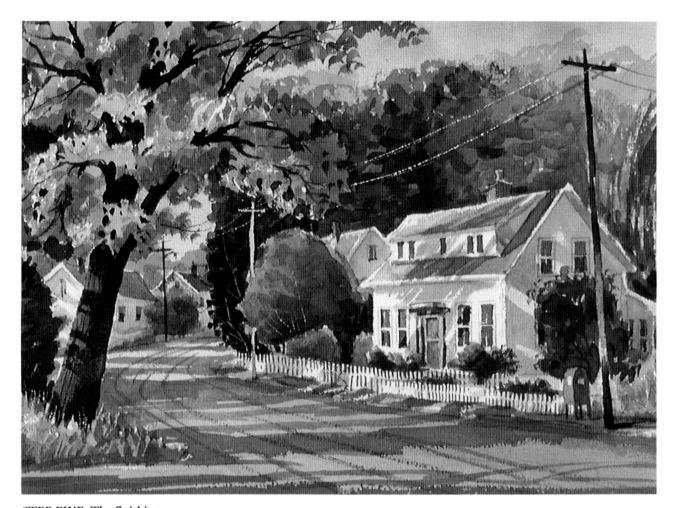

STEP FIVE. The finishing touches bring the painting together. I've framed the house both by value contrast and shape/line arrangement. The tree trunk and telephone pole frame the house on the sides. On the top and bottom the white fence and scratched-out white telephone wires do the same job. But the easy curve of the road going back gives you an entrance to even the most distant areas of the painting to keep you interested.

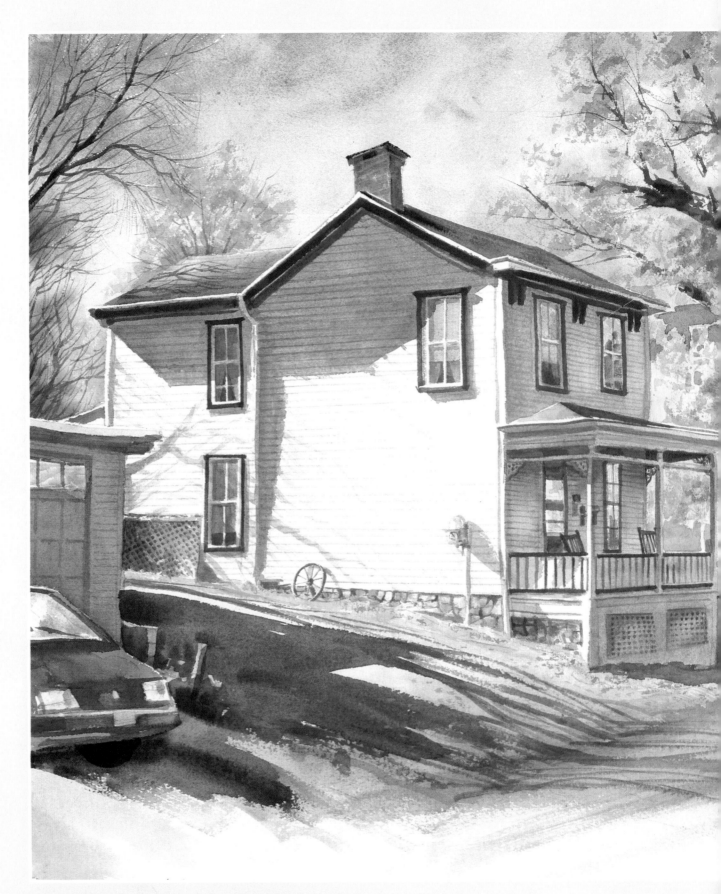

SWAN STREET, LAMBERTVILLE, NEW JERSEY, 22 × 30″

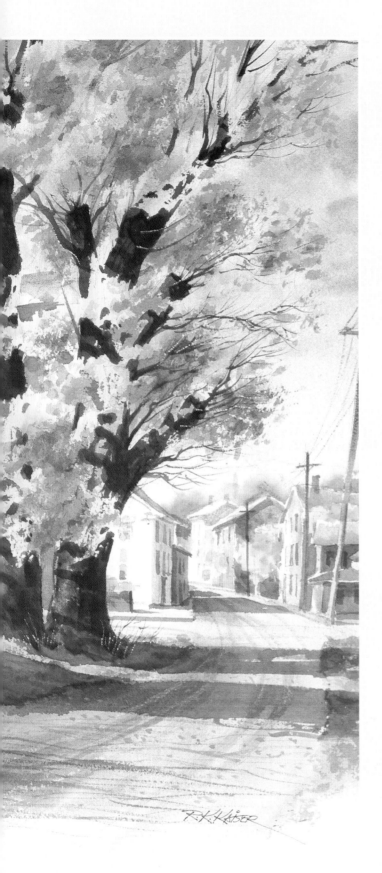

ADDING SEASONAL COLOR

After designing your painting and getting your values right, your next important decision will be about color. One of the biggest influences on the color of a scene is the season. In this chapter, after discussing some color basics, I'll show how to express the season through your color choices. I've suggested a color palette for each season and used the colors in paintings representing that season. But these are merely suggestions. You can always add or subtract colors according to your preferences.

COLOR BASICS

For a really thorough study of color, I recommend reading one of the many books for artists that deal just with color. I'll cover the basics here.

Each person deals with color in his own way and has his own color temperature gauge. Some people will emphasize blues, or cool hues, in their paintings, while others will head for the reds, or warm hues. Let your colors come out of you the way you feel. This is one way to put yourself into your painting. But understanding color in general will help you make the appropriate color choices.

The color wheel below left is one way of showing how colors are related to each other. In a painting, colors exist next to other colors. Each color affects the other.

In the color wheel below right, directly across from each color is its *complement*, sometimes referred to as its "friendly opposite." Each *primary* color is always complemented by a *secondary* color. When you're painting, try to remember the primary colors and complements and use them intelligently. One color will always make its complement look brighter when placed next to it. However, when complements are mixed together, they make various colors of gray.

It's also important to keep in mind the three principal aspects of color. They are:

1. *Hue*—This refers to the specific name of a color; for instance, green, blue or brown.

2. *Value*—This is the darkness or lightness of the color. Each color has a value. Different hues can have the same value. This is important to consider when trying to match a value study.

3. *Intensity*—Sometimes called "chroma," this refers to a color's weakness or strength. For instance, the green hue in the tree can be a bright green or a dull green, which is perhaps a gray with a green cast. In turn, that dull green can be either a light or dark value—it could be a whitish green or a blackish green.

Different colors tend to advance or retreat. You will probably notice in scenes around you (and in paintings) that warm, darker colors give the illusion of coming forward, while the cool, lighter colors will recede. You can use this attribute to show depth in your paintings.

QUESTIONS TO ASK

People have asked me, what is your outlook on color? As I've said, each person has a personal color temperature gauge. For me, my first impression of a scene, the design and patterns in it, and the sunlight playing on it tell me what to do. I try to be accurate in my own representation of a scene or subject.

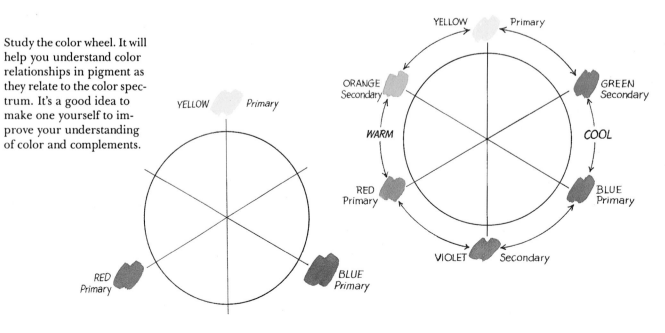

Study the color wheel. It will help you understand color relationships in pigment as they relate to the color spectrum. It's a good idea to make one yourself to improve your understanding of color and complements.

YELLOW Primary

RED Primary

BLUE Primary

YELLOW Primary

ORANGE Secondary

GREEN Secondary

WARM

COOL

RED Primary

BLUE Primary

VIOLET Secondary

Paint what you see and feel, not what you know. You may know that water is clear, but if it looks nearly black, paint it that way. Go outdoors to paint as much as possible and let the scene tell you what to do. Study the effects of light on everything. Don't show only what the scene looks like, but also how it feels. When you're looking at an outdoor scene, ask yourself these questions:

• How much light is there in front of you, and what color is it? Sunlight is really not white. It contains all the colors of the rainbow. If a beam of sunlight is shone through a prism, it will throw a rainbow of red, orange, yellow, green, blue and violet.

• If it's sunny, is it bright? Or is it hazy, or partly cloudy? Is it raining or snowing? Every type of weather will affect the color of the scene in front of you.

• What is the *value* of the subject in front of you? Value is the degree of darkness or lightness in a scene or area. Try to keep your painting to five simple values. Think of 1 as a white value and 5 as nearly black.

• Is your scene or subject warm or cool? This will also be affected by the weather. Cloudy, rainy or snowy weather will emphasize the cool tones in your scene.

• What is the main or dominant hue (red, blue, yellow, etc.)? This will be determined by a combination of subject matter, light and weather conditions. Is this hue bright or on the gray side? Look at your palette and see which pigment will be closest to what you see in front of you. You can darken it or add water to lighten it.

• What is the local color you see in the scene? Local color is the actual colored surface of an object or subject. Try to reproduce the color as closely as possible. Remember, the atmosphere will affect color. The color on a cloudy or rainy day will be dull compared to the same color on a bright, sunshiny day. The color you put down should tell the viewer what kind of a day it was when you painted the scene. This should also determine the kind of visual mood you want to impart.

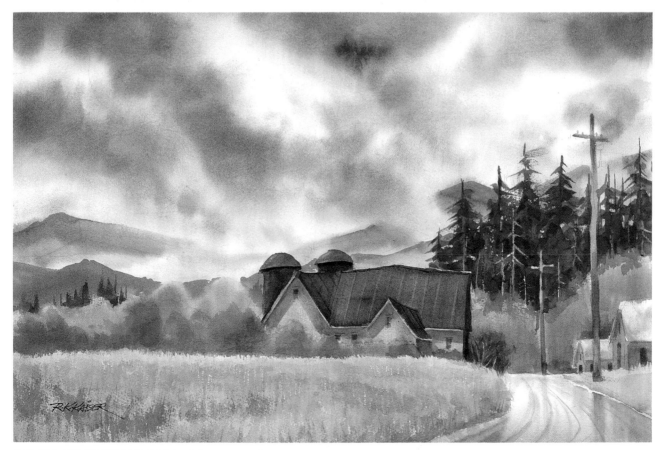

STORM, GREENVILLE, NEW YORK, 15 × 22″

COLOR FOR THE SEASONS

Each season can be seen as possessing a unique natural harmony of color that is influenced by the special light and atmosphere of the time of year. Sometimes a painter will not see this and will paint just what he *thinks* he sees: The sky is "blue," therefore he paints it blue, right from the tube; the grass is "green," so he paints it green, from the tube; the tree is "brown," brown paint from the tube. We become trapped in these preconceived images, forgetting to look at what light and atmosphere do to a scene or object. Any scene will be strongly affected by both time of year and time of day.

On the following pages, I've suggested a simple color palette for each season. These are meant as a departure point—not as a strict rule. It's true; you might use more blues in a winter scene and use more greens in a spring scene. But don't use plain blue and green. Use the paints in values and gradations to show what you want us to feel about the season of that scene or object.

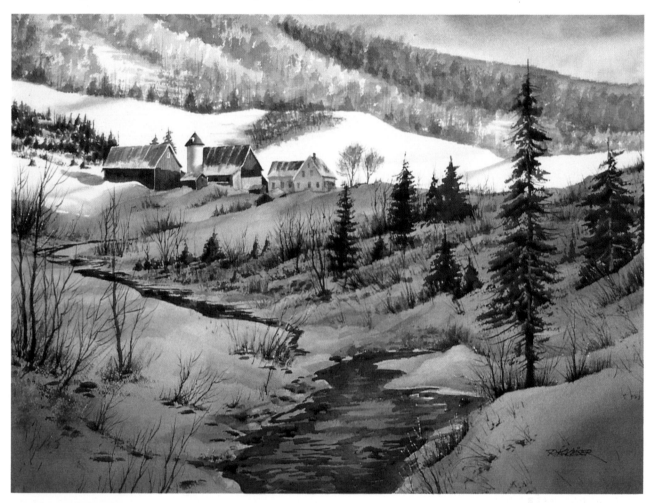

FARM ON THE MOUN-
TAIN, PISGAH, NORTH
CAROLINA, 22 × 30″
There is nothing as satisfy-
ing as capturing a clean,
crisp winter snow scene in
watercolor.

WINTER

Ultramarine Blue Burnt Sienna Alizarin Crimson Burnt Umber

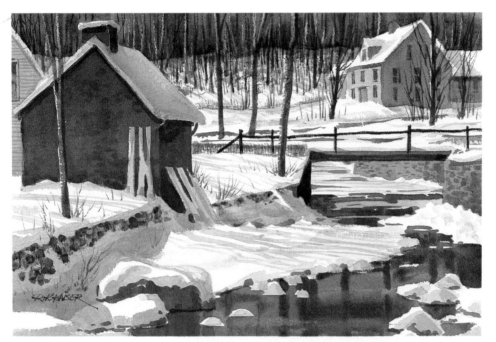

WINTER IN NEW HAMP-SHIRE, 10 × 14″
In winter, cool colors will be dominant. This was a crisp, snappy, cold morning and you can almost feel it. That sunlit snow with all the cast shadows really makes the scene come alive. I've added some cool blues and violets to the shadows because shadow colors are not just dark, dull gray. The warm neutral tones of the background house and trees also suggest a sunlit day.

THE OLD ONE, 10 × 14″
Snow, trees and shadows are such fun to paint. Notice how the blue-gray faraway trees seem to recede into the distance, and how the green fir and brown of the old tree come forward. The cool cast shadows create the form of the snowdrifts. The little touch of red on the twigs in the foreground adds a warm sparkle to an otherwise cool painting. Warm accents like these help relieve the almost monotone palette of a winter painting. You can also find color in the few leaves left on some of the trees.

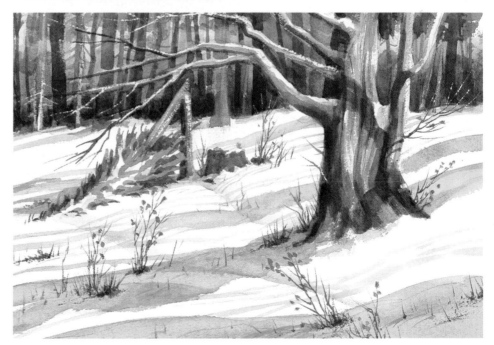

SPRING

| Ultramarine Blue | Cerulean Blue | Burnt Sienna | Hooker's Green Dark | Raw Sienna | Cadmium Red Light |

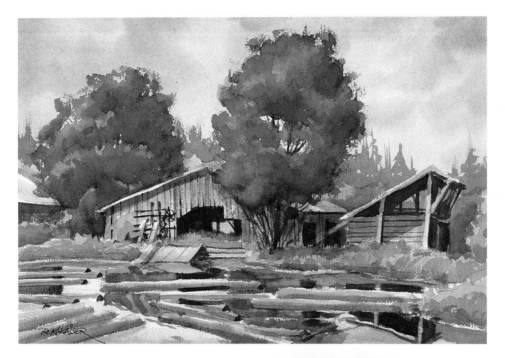

LUMBER MILL, JEFFERSON, NEW HAMPSHIRE, 10×14″
Spring has sprung in Jefferson, New Hampshire. Everything just "blossomed up," and you can almost smell the grass and trees. There are lots of greens, but spring greens are often purer and richer than summer greens. Yellow-greens often prevail in early spring. Next time you are outside, look at all the trees and bushes. Observe all the different shades of green in front of you. The bright, clear sky also helps this painting show a "spring day."

COTTAGE ON THE HILL, 10×14″
Notice all the different colors of green and brown and red in the meadow leading up to the cottage. The suggestion of lots of wildflowers in the meadow clearly says "spring." By mottling the grass, I suggested a lot of detail where there really isn't any.

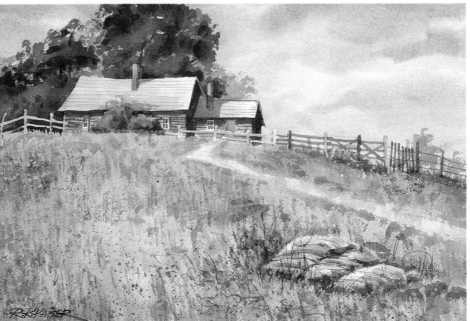

SUMMER

Ultramarine
Blue

Burnt
Sienna

Hooker's
Green Dark

Raw
Sienna

Burnt
Umber

Permanent
Rose

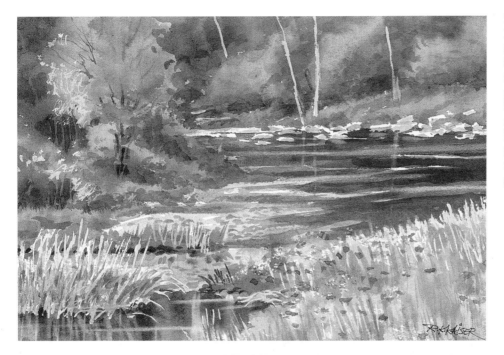

BY THE STREAM, 10 × 14″
It's a warm summer day by a trout stream. The greens in the painting are still on the bright side, but a few greens tend toward yellow-brown. As summer goes on, most greens go toward brown. Control your greens. Don't make a summer painting just a "big green monster."

THE PASTURE, HAMILTON, NEW YORK, 10 × 14″
Just suggest those faraway trees. Don't paint a portrait of each one. Again, watch that your greens aren't all the same. Here I've alternated values of green from light to dark and dark to light to give the feeling of depth (the hill) and form (the trees). The pervasiveness of green—almost an overgrown look—will give your paintings a summery look.

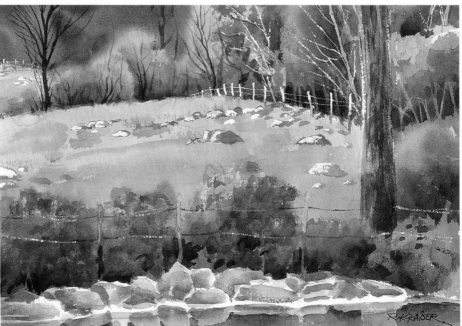

FALL

| Ultramarine Blue | Cerulean Blue | Burnt Sienna | Cadmium Orange | Gamboge Hue | Winsor Yellow | Alizarin Crimson |

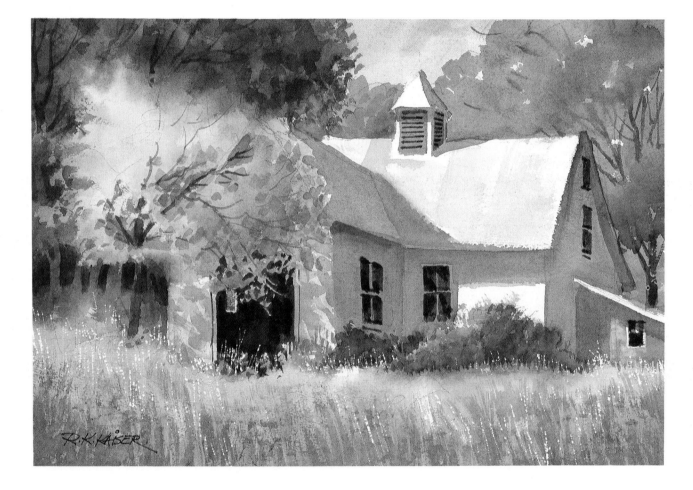

R.K.KAISER

FALL AND BARN, 10 × 14″ It's just a white barn and a few fall-colored trees, but look what you can do with color. The white barn has a lot of shadow area into which I've flowed various colors reflected from the surrounding grass and trees. The coolness of these shadows brings out the brilliant warmth of the trees. But be careful not to get too garish with your warm autumn colors. Nature's colors, though marvelously bright, are seldom pure hues. Use your brightest colors sparingly.

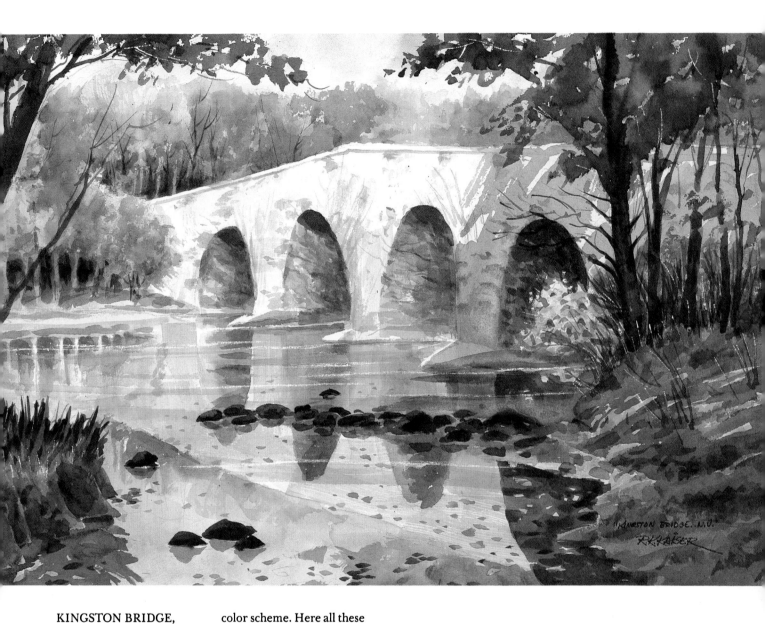

KINGSTON BRIDGE,
NEW JERSEY, 15 × 22"
The early fall, when only
some of the trees have
turned, is a beautiful time to
paint. The complementary
contrasts of the remaining
green leaves with the newly
turned leaves of red, orange
and yellow make an exciting
color scheme. Here all these
contrasts are kept from be-
ing overwhelming by the
large neutral areas of the
bridge and water. It's im-
portant to remember how
helpful neutral colors can
be—especially during the
bright-colored autumn sea-
son.

PUTTING LIGHT IN YOUR LANDSCAPE

Light is probably the most sought after but elusive effect for most artists. How do you interpret the different kinds of light and make the viewer aware of it in the painting? Start by making a study of light, how it strikes a scene or an object, and how it forms shadows to define shape and form. The angle of the shadows will usually tell you the time of day—morning, noon, afternoon or dusk. Light will also tell you about the weather and what kind of day it is. The sun in the morning gives a certain quiet warmth to its slanting rays. The hottest sun at midday gives the whitest light. The slanting rays of the setting sun cast soft violets and other cooler colors. Doing a black-and-white halftone will make you aware of the light in the scene and the relationships of the light and dark values. In this chapter we will explore several techniques that give the illusion of various kinds of lights.

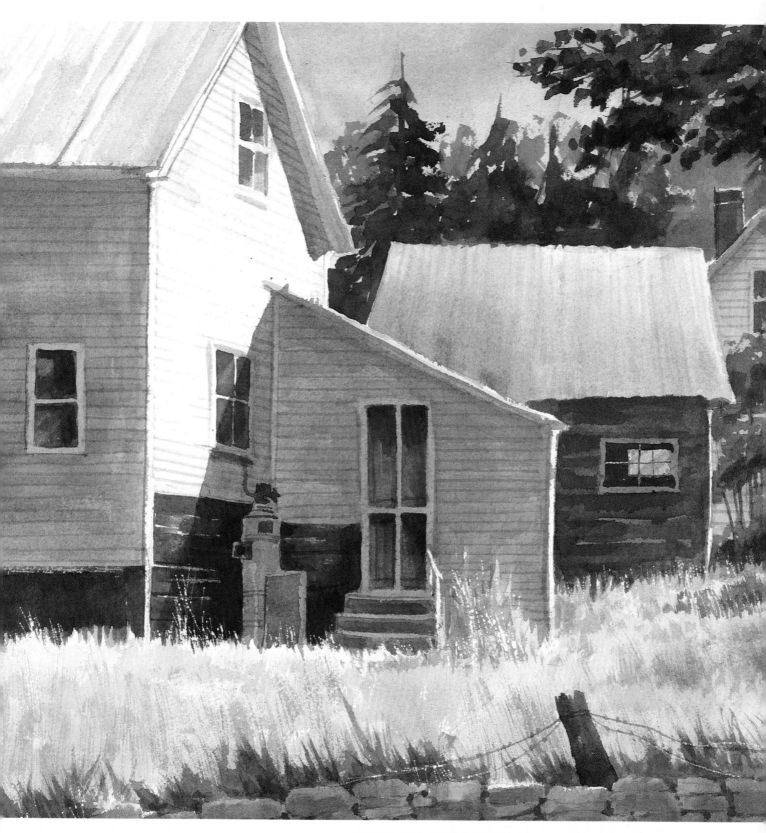

HOUSE AND SHEDS, FREEDOM, NEW HAMPSHIRE, 15×22″

TOP LIGHT

On a clear day at noon, sunlight tends to be yellow-white. This is the brightest part of the day, and the sun, being directly overhead, forces a sharp downward contrast on anything it shines upon. It also throws lots of reflected color into the shadowed areas. This reflected light will show the color of whatever is next to the shadow.

Top light is quite different from sunlight that falls at other angles. I usually prefer the angles of the morning or afternoon sun. But you can sometimes get some great paintings when the sun is directly overhead.

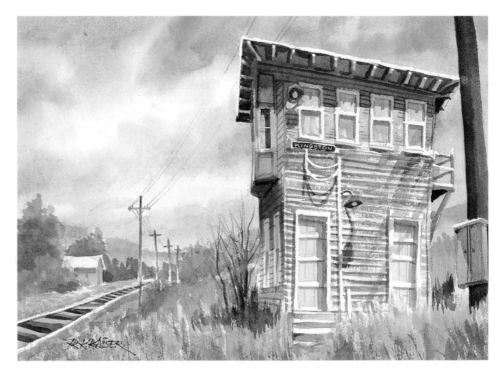

KINGSTON RAILROAD TOWER, 10 × 14″
This interesting railroad tower of a bygone era is made of a lot of weather-beaten boards. The top lighting, with its tendency to show lots of detail, emphasizes the "beaten" quality, revealing how old this building is. Top light also usually minimizes overall value contrasts. Note that the painting is basically in a mid-value range. For this reason it can be difficult to create an interesting composition under top lighting conditions. But that's no reason to avoid it. I added some color by making the sky and clouds bright.

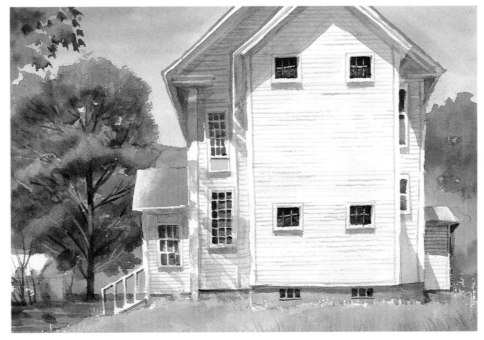

HOUSE, STONINGTON, CONNECTICUT, 10 × 14″
Top lighting can force you to add color to your shadows. In this painting, note how the dark areas still say shadows but contain a lot of warm reflected light. This is one of the best effects of top lighting. I went from light to dark and from dark to light to solidify the scene. Leaving some of the grass white also suggests the bright overhead sunlight.

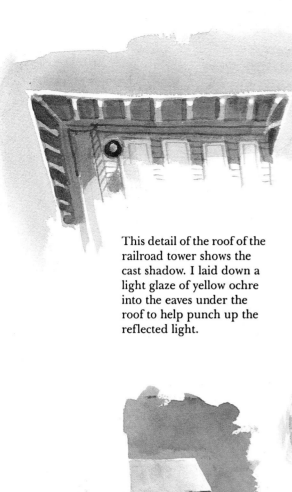

I've put a cast reflection of the roof stays in the window on the right, plus a little vertical cast shadow of darker cerulean blue.

I've left a lot of white in the clapboards and accentuated the cast shadows underneath to emphasize these boards. Leave as much white as possible to show direct light on a subject.

This detail of the roof of the railroad tower shows the cast shadow. I laid down a light glaze of yellow ochre into the eaves under the roof to help punch up the reflected light.

Most of the side of the building is in shadow from the overhang on the tower. But I've gradated it to keep it from being flat. There are a lot of different colors in the shadow area of the grass. In nature, objects also pick up color from reflected light. Incorporate more colors to enhance grass and foliage.

Sunlight hitting the Stonington house creates an angled pattern of lights and darks on these set-back portions. The color in the shadow areas reflects the color of the grass. I've left out a lot of the clapboard lines. You don't have to put them all in to suggest that they are there.

The steeply angled gable creates an angled cast shadow on the white clapboards. The subtle yellow tones add warmth to the cast shadow.

The green on the roof is gradated from light to dark, and I saved the whites along the edges. The colorful cast shadows on the side of the house help to establish form, create interest and indicate direction of sunlight.

BACKLIGHT

When the sun faces toward you, it tends to make silhouettes of everything, creating strong value contrasts and minimizing color. Shapes predominate, and you have to punch up your color to avoid making them all black. Objects facing the sun will mirror it. Their angle will determine how much light they reflect. Observe the smaller objects' light, but don't let them take over the scene. The main point of interest, often silhouetted against a bright sky, should stand out.

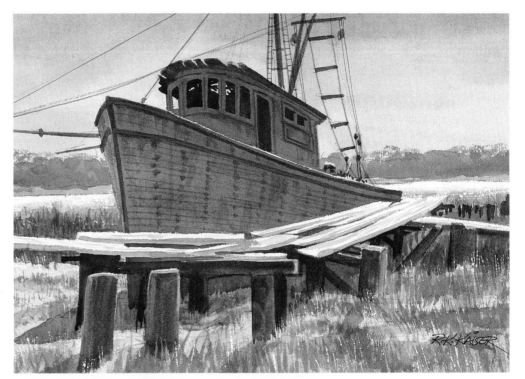

SHRIMP BOAT, HILTON HEAD ISLAND, SOUTH CAROLINA, 10 × 14"
On this hot day the bright sunlight was coming right at me. The bright light made the planking appear white and raised a hard white light along the edge of the boat in front of the cabin. Some of the grass showed white as it sparkled with the sun on it. I purposefully filled the dark silhouette shape of the boat with lots of reflected color, though at times it appeared almost black. Backlighting conditions create a visual strain but can produce very dramatic compositions.

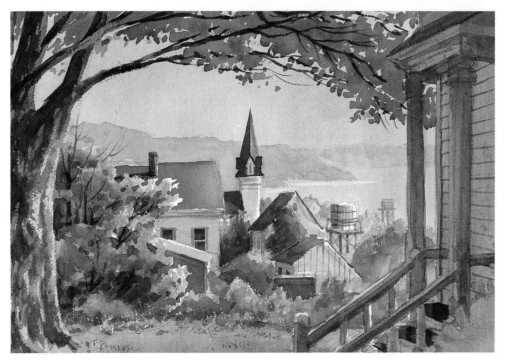

MENDOCINO, CALIFORNIA, 10 × 14"
This tiny coastal town has such great sights. It also has been quite an artists' colony for many years. This shows a different use of backlighting. Instead of silhouetting a large central shape, the backlight here has made a frame out of the objects in shadow—the trunk, leaves and house's entrance. This helps us feel a part of the scene and makes the distant view more interesting.

For the sky area behind the boat, I painted a wash of ultramarine blue, and while it was wet, touched it with yellow ochre, then put it behind at the skyline. When it dried I laid in a light wash of light yellow-green for the faraway trees. Do all the work on the sky and background before painting in your backlighted object.

Keeping the boards quite white (with just a little gray to show form and texture) against the dark of the boat and grass helps show how bright the light is. Notice the drybrush effect of ceru- lean blue for the water. If your initial brushwork doesn't go down perfectly you can take a razor blade and scratch it over the blue to give the effect of spar- kling water.

I kept the edges of the pil- ing quite light to show the sunlight hitting the other side. I've added a touch of cerulean blue to one side to cool down the post. Even in bright sunlight there will sometimes be a cool color thrown on a shadowed side.

To show a warm, glowing background of hazy sun- light, I put down a wash of yellow ochre and lightly flowed another wash of Payne's gray into it, adding a slight touch of ultrama- rine blue to some outer parts. The light washes of the coastal lands are made up of ultramarine blue and burnt sienna. One headland is lighter than the other, as it's farther away. I also lifted a couple of white lines out of the water wash to show surf near the base of the headlands. Keep the washes of trees and buildings light, as they are farther away from your foreground sub- jects and are bathed in sun- light.

To show reflected sunlight I've added a lot of warm yel- low ochre in the white shad- owed sides of the buildings and saved a lot of whites on the trees and roof edges.

SIDE LIGHT

When sunlight strikes an object from either the left or right, the shadows cast emphasize the object's form. They also make patterns that can be used by the artist to direct the viewer's eye to the center of interest. The shadows created when side light hits a form tell the viewer whether that form is square, round, triangular or some other shape. Because of the effects of side light, early morning and late afternoon have long been favorite times for a great many artists to paint.

HOUSE ON DEFUSKY ISLAND, NORTH CAROLINA, 10 × 14"
This small island off the coast of North Carolina can only be reached by boat. Until a few years ago, only fishermen and their families lived on it, and it was quite rustic. The house itself has tremendous textures and angles to it—a good subject for side lighting. In particular, the texture of the corrugated tin roof is revealed by the light coming from the right. In this case, the shadows from the sun are complicated by the cast shadows from the tree.

The interplay of sunlight and shadows shows the texture of the roofs. I've left as much white as I could to show the sparkle of sunlight and the angle of it from the right. I've left some holes in the shadows because trees are not solid. Their leafy foliage allows spots of sunlight through to even heavily shaded areas.

Tin roofs are always fun to paint. Their corrugated tops make all shadows hitting them interesting. Note the shadow's edges on the top and the shape of the cast shadow on the side of the building. If you weren't sure the roof was corrugated, the shadows would sure tell you.

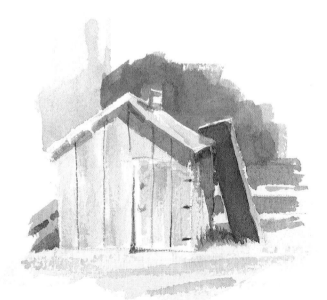

I kept the little shed quite simple, leaving white whenever I could. The can on top was a funny touch. The red piece of sheeting makes a nice contrast (cool vs. warm) and throws a red into the shadow it casts. The light from the right defines the planes very clearly.

FOGGY DAY

Foggy day paintings are tricky but fun to do. Everything looks diffused. Moisture in the air becomes so thick and dense that you can actually see it. Colors get lighter and grayer as they recede. Values move toward midtones. White becomes gray and black becomes lighter in color. Foliage that up close to you appears green looks faded or dull a short distance away. Objects become mere shapes, softly colored. Study the values in front of you very carefully. This is a great time to do a black-and-white halftone, a small sketch in either pencil or watercolor to figure out the scene.

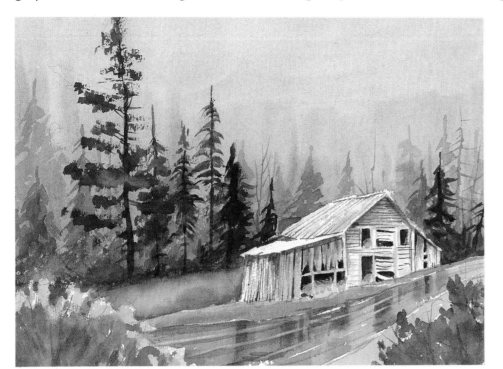

TOBACCO SHED, ASHEVILLE, NORTH CAROLINA, 10 × 14″
All around the area of Asheville are the Smokies and the Pisgah Mountains. Usually on fall mornings they get a lot of fog. It makes a very dramatic scene to paint. Everything is subdued and quiet. Note the muted colors and the misty feel of the trees peeking through the fog. The warm yellow-brown of the drying tobacco provides the center of interest—and visual relief from all the subdued values.

FOG AT GOTT STREET, ROCKPORT, MASSACHU-SETTS, 10 × 14″
Rockport, being on the ocean, gets quite a few foggy days. Instead of showing wharfs and boats, I thought I would show one of the streets in the town. You can see how the bush up close in the left foreground is bright green. But the colors very quickly fade to gray as they recede into the distance.

To paint this foggy background, wet the sky area up to the foreground of your painting. Lay down a light wash of yellow ochre first, then Payne's gray over it (or a mixture of gray made with ultramarine blue and burnt sienna). While it is still wet, float in a darker mixture of gray to indicate faraway trees and then let it dry. Take the same mixture of gray and apply it now to the dry surface of your background, as on the left. It should give you a slightly darker value for trees when applied to your previous wash (the ones behind the darkest trees). Let them dry. Then mix an even darker wash of gray and apply it over the first and second washes of trees as in the two darker trees on the left. Let all these washes dry, then add the darkest and most important trees. The greens I've used are colorful in comparison to the grays but still subdued, not bright.

Here's another foggy day in a different area of the country. The shapes of the background trees are very subtly indicated with subdued colors, while the foreground trees and foliage are silhouetted with stronger, but still subdued, colors.

You can make out the shapes of faraway houses down the street, but you can't see too much detail. Edges are softened and values tend toward midtones as the fog diffuses the light.

A very light wash shape makes you conscious of the background trees, while a little more detail of branches, fence and telephone pole says "foreground."

BRIGHT DAY

The clear, intense light of a bright day tells you and your viewer the most about the details and colors of your scene. It produces the strongest contrast between sunlit and shadowed areas. Whites are pure and brilliant, colors are luminous, and details and textures stand out clearly. As you paint the scene in front of you, be aware of this. Don't make all the elements of your painting stand out so much that they start fighting each other for attention. Choose your point of interest and make the whites and colors at that point the clearest and strongest to attract the eye.

Bright days can be hazy, too. Hazy sunlight on a hot summer day makes everything appear diffuse. The shapes are there and the color, too, but just a bit less intense than on a clear, dry day. As you paint on a bright, hazy day, think "high key." Everything should be in the lighter end of the value spectrum. Tone down your colors slightly, and keep the shadows softer edged and not too dark.

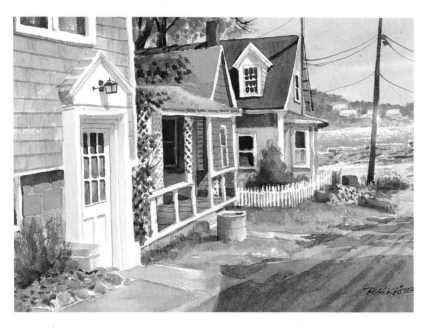

HOUSES, ROCKPORT, MASSACHUSETTS, 10 × 14″
It was a bright, "sparkly" day, and the bungalows along some of the streets of Rockport shone with color and clarity. Lots of white, sharp edges and the use of bright colors, even into the distance, help to make the bright-day effect.

CAPTAIN TWO BILL'S, SAVANNAH, GEORGIA, 10 × 14″
This painting communicates the feeling of a bright, sunny day because of its strong value contrasts between shadowed and sunlit areas and its bright colors—even in the shadows. Look how rich the violet and blue-violet shadows are on the buildings behind the boat.

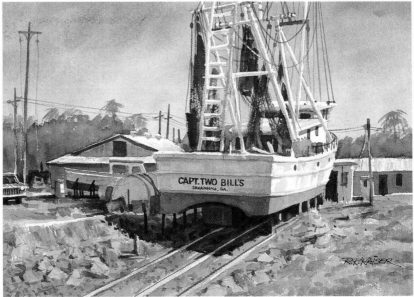

The bright white of the doorway starts you into the painting. I added a slight wash of yellow ochre to warm the shadows but kept everything else the pure white of the paper.

A bright-day sky may be clear and blue but still have cumulus clouds building on the horizon. The clouds are dazzling white on top and many shades of colorful gray underneath. Wet the background with clear water, then paint a very light wash of raw sienna on it. This makes the whites a sunny yellow. Paint around some of the clouds in ultramarine blue, and while it's still wet, add a mixture of Payne's gray and alizarin crimson for shadows under the clouds.

Bright light produces lots of bright white and gradated tones. Shadows are crisp and sharp-edged. The overlapping of darks and lights helps to give that feeling of sunlight and shadow.

On a bright day, light reflected onto vertical surfaces is loaded with color, as on the walls of these buildings. Also look for the lines of white that are abundant on a bright day. These help you enter and exit the painting.

RAINY DAY

Rainy days are also fun to paint. Some say there are no shadows on a rainy or cloudy day but there are. They are just more subtle, and so is the color. Sunlight high above the clouds filters through and strikes the landscape in a soft, diffused way. Study the houses in the paintings below—you'll see definite shadows under the eaves and rooflines. Under trees and porches and cars, the shadows are even more apparent. The color is there, too, but it's softer and darker. Colored objects reflect their own color in the scene, especially on rainy streets and in puddles.

The light of a rainy day also has the look of overcast, snowy scenes or dark, wintry days. In each of these cases, values tend toward midtones, colors are subdued, and shadows are soft.

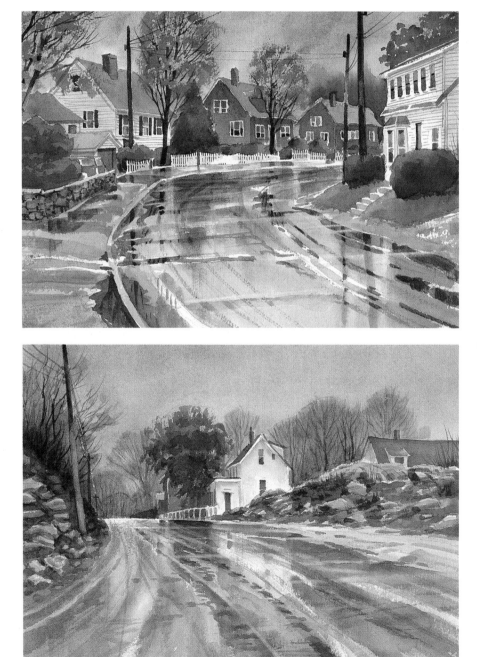

RAIN ON ROCKPORT, MASSACHUSETTS, 10 × 14″
Rainy days give us the opportunity to paint colorful reflections and to experiment with many shades of gray. But it's really the whites here and there in the reflections and puddles that make a great rainy-day scene.

TOP OF THE HILL, ROCKPORT, MASSACHUSETTS, 10 × 14″
I used a limited value range and color palette to silhouette the house, making it seem bright in comparison. Long brushstrokes indicate tire tracks on the wet pavement.

To paint a rain-covered street, start by wetting just the street (after you've done the buildings, sky and trees). Quickly touch in the colorful reflections of the trees and buildings, leaving whites for tire tracks of the cars. Make the puddles dark, leaving the street itself a lighter gray than the puddles. When it's dry, go back and add some horizontal washes for shadows, and use a stipple brush to lift out whites. Let it dry again, then enhance your colorful building reflections. When that's dry, add a few light drybrush strokes of gray to enhance the white tire tracks curving through the street. The reflections of vertical objects, like telephone poles and tree trunks, will appear as a mirror image broken into segments. The reflections will always be darker in color in the puddles.

For a rainy sky begin with a light wash of yellow ochre and mix a wash of Payne's gray into it. Now add a little ultramarine blue and a little burnt sienna for a mottled, cloudy effect.

For a darker, more threatening sky, start off with a wash of yellow ochre and then add Payne's gray, or mix a wash of gray using ultramarine blue and burnt sienna. Wash the gray over the yellow ochre to the darkness you want. Add a little more yellow ochre to the horizon area to silhouette the trees.

Even on rainy or cloudy days there are still subtle, soft-edged shadows. Here I've added blue-gray washes under the roof eaves, then used clear water to fade them off to nothing.

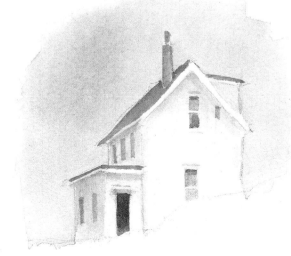

TWILIGHT

Painting by the light of the setting sun is enjoyable and has produced many award-winning scenes. Yes, there are special problems that arise at these times, but by planning ahead and working quickly, you can conquer them. If you are painting outdoors, the light changes more rapidly at this time of day than at any other. (Here's where a camera will come in handy.) Scenes painted during twilight are usually low key (on the dark side). Showing a warm glow in the sky with crimson, magenta and violet colors is one way to get the effect of twilight. Houses can be silhouetted against the sky, and you can put lights on in the windows. To show lights on in a house, or reflected light in puddles, or even highlights of rooftops, first mask out these areas, then paint around or over them. Keeping whites on your paper is important, even for a scene painted in twilight.

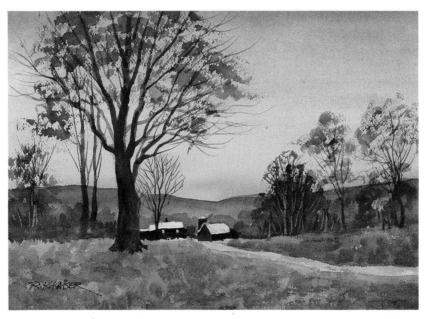

BERKSHIRE FARM, MASSACHUSETTS, 10 × 14″
This is a lovely area in which to paint — quaint little towns plus beautiful mountains. I've tried to capture the softness of the scene by using low-key colors on the cool side. Twilight paintings are a special kind of backlight painting. Often the sky remains colorful and bright, while the darker objects of the landscape stand silhouetted against it.

NEW HAMPSHIRE FARM, 10 × 14″
The sun is just going down, the chores are done, and the farmer and his family are having dinner. I wanted to capture the quiet of early evening in this painting. A lot of reflected sky light is on the roofs and sides of buildings and the grass, but the bulk of the painting is in a low (darker) key. The lightest areas are the sky and the windows.

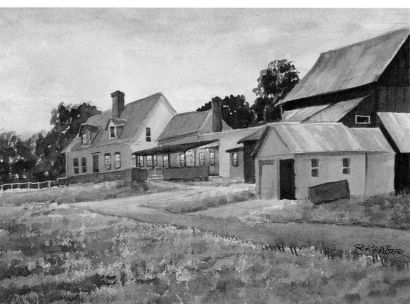

To paint a twilight sky, first wet the whole sky area with clear water. Then start at the horizon and work upward with a light wash of alizarin crimson. Add cadmium orange, then cadmium yellow, then cerulean blue, mauve, and then on to ultramarine blue, and finally a darker mixture of ultramarine blue. To help the blending, tilt your paper upside down so all of the washes head toward the ultramarine blue.

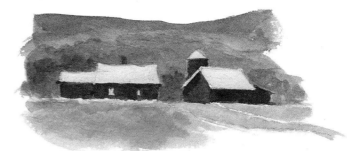

Keep the roofs light against the darker burnt umber of the trees. The cerulean blue wash reflects the sky and makes it the lightest spot in the darkened scene, except for the lit windows. Light from the windows lightens the grass below the windows.

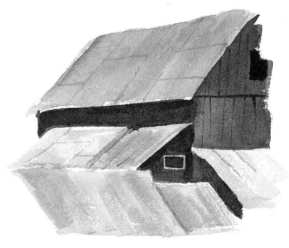

Trees painted at twilight should be quite dark to stand out against the sky, but lighten the side of the trunk that faces the setting sun. Indicate branches heading toward the sun with lighter washes of burnt umber.

The big barn roof should be dark enough to silhouette it against the sky, but light enough to reflect the waning light and to contrast with the darker vertical walls.

NIGHT

Nothing can be more dramatic and unique than night scenes. But they can also be tricky because there are usually several different light sources. This will be multiplied when the lights reflect off rooftops, sides of buildings, windows and rainy street puddles. For a night scene, plan to do a value sketch. Your careful study will pay off. Even in a low-key painting, you'll need to save your whites. Probably the best way to start your painting is with a medium or middle-dark tone. In the daytime you usually work from light to dark, with one light source. But in a night scene you have many different light sources to contend with. Make sure that you leave a lot of light around the light source and subdue the rest of the painting. The warm yellow-white of incandescent lights and the cool blues and violets of the night sky provide the dramatic contrast that make night scenes so intriguing.

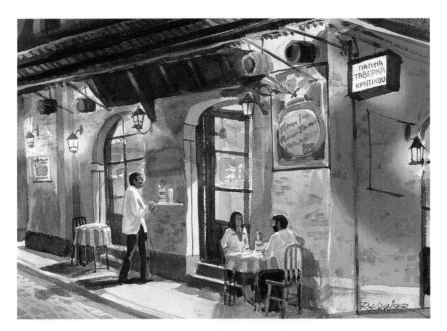

KRITIKOS'S TAVERN, GREECE, 10 × 14"
Check the angles of light hitting objects and casting shadows. Often shadows will go in multiple directions in night scenes. Also note the golden halo around each lamp—and how the light drops rapidly to dark as you move away from the light source.

LE CONSULAT, MONT-MARTRE, PARIS, FRANCE, 10 × 14"
Montmartre is home to many artists and writers. The hustle and bustle of the day here continues into the night. Areas like this are well lit, and there seems to be a dividing line of value change between the street level and the darker area above. Notice how the eaves of the buildings are bottom lit with warm light coming from below.

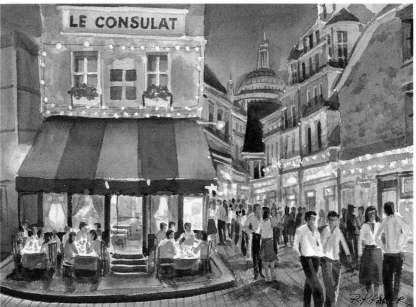

To make a halo of glowing light, start with a circle of clear water over the light to about a one-inch radius from it. Next add a wash of phthalo blue darkened with a light touch of alizarin crimson. Float the darkened wash all around the clear water areas, just touching it. The blue dark tone will diffuse immedi-ately and cause a halo effect. Absorb a little of the blue with a clean wet brush if it invades too much into the clear white area. After this is dry, lightly brush a soft wash of cadmium yellow over the clear white halo that was left. Keep the center of the lamp pure white to make it look quite bright. Add the black fixture last.

I've left the top of the woman's head, her shoulders, and parts of her arms pure white to indicate the direction of light from the tavern's doorway. Reflected light from the tablecloth lights up her face.

The waiter and the front of his jacket strongly reflect the white light from the doorway, while the back of the jacket reflects the soft yellow glow of the lamps.

To paint well-lit buildings at night, leave the railings or eaves pure white. Paint a warm blue-gray wash over all the fronts and sides of the buildings. When this is dry, add the dark shadows coming up from the street over parts of the fronts of the buildings. I've kept the shadow narrow near the street, and as the building gets higher, I've made the shadows higher and deeper. When the shadow washes are dry, go back and add your windows. Then add a light yellow wash to the white fronting eaves or railings. A very light wash of the same yellow on the fronts of the buildings indicates reflected light from the street.

REFLECTED LIGHT

The light in your scene does two things: It illuminates your subject and it reflects off the subject. Wherever there are shadows made by sunlight there will be reflected color from the surface right next to the shadow. This will be very apparent in a street or alley scene. Sunlight hits the building on one side of the street and leaves the building on the other side in shadow. The local color of the building hit by the sunlight will be thrown into the shadows of the other building. On a sunny day, go out and observe this phenomenon. Some painters always make the shadows in their paintings gray, black or blue. When you look at these paintings, you may think, "There's something wrong. They don't look quite real." You're right. Your "inner eye" is telling you that the scene lacks authenticity or truthfulness in its representation. There is color all around us. Study, observe, look, and look again. The color is there. You just have to be more aware of it. When you start to add color to your reflected light, you will see your paintings spring to life.

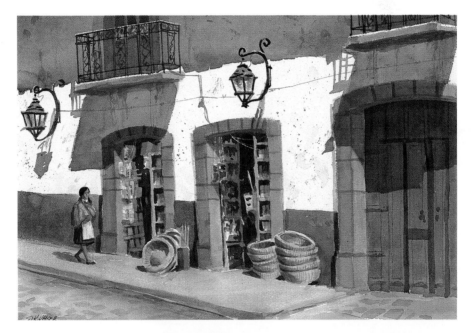

STREET IN PATZQUARO, MEXICO, 15 × 22″
What a marvelous town to paint in, about seven thousand feet up in the mountains of central Mexico. This typical street scene gives you the feeling of the hot day and the white stuccoed buildings in the town. See how much warmth is reflected into the shadows from the color all around?

PURITY SPRINGS HOUSE, NEW HAMPSHIRE, 10 × 14″
From hot Mexico to cool New Hampshire. This little, old house nestled in the pine area of Purity Springs offered a wonderful opportunity to practice painting reflected light. White surfaces, in fact, probably show the most colorful reflected light. Notice both how many colors are used in the shadows and how strong they are without appearing out of place. Look at the color of the porch ceiling.

For the shadow area over the balcony, I quickly floated in a wash of ultramarine blue and burnt sienna. While it was still wet, I floated into it yellow ochre and alizarin crimson to add warmth to the shadow area. The pure white edge along the balcony shows that the top of it is bathed in hot sunlight. The cadmium orange stroke under the balcony and the underside of the doorway also indicates the reflection of bright sunlight from the street below.

For someone standing in a brightly sunlit street and peering into an open doorway, the interior will appear, by contrast, very dark. But look again—reflected light from the street illuminates not only the doorway, but objects just inside, too. Here, after I laid down a burnt sienna for the shelves, I floated a wash of ultramarine blue and alizarin crimson over the top half of the shelves to push them back into the darkness of the doorway.

The cast shadow under the roof eave was made of ultramarine blue and burnt sienna. While it was still wet, I floated in yellow ochre and a little alizarin crimson to suggest the warm reflected light from the porch roof. I added a wash of yellow ochre and cadmium orange to the porch ceiling.

INDOORS, LOOKING OUT

Here is where your study of light and light source, of reflected light, and of objects being hit by these lights will be challenged. Reflected light from outside will enter a room or area and illuminate the objects in it but with differing amounts of light. This means some objects will be more important (nearest the light source) and others will fade in importance (farthest from the light source). A quick thumbnail sketch will help you sort out the wide range of values.

When the scene outside is more important, the objects in the foreground have to take a backseat. But remember the foreground objects should set the stage for your visual track to the point of interest (outside). Keep the foreground somewhat quiet—quiet in color and quiet in importance. Study your foreground and find out what you can leave out or tone down in importance.

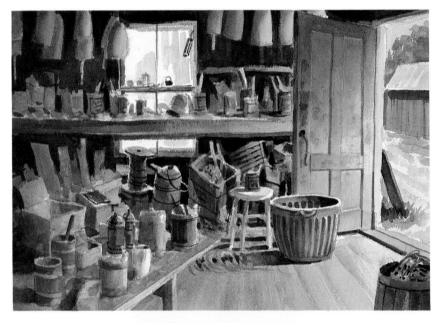

R.J. OLSEN'S SHACK, CUSHING, MAINE, 10 × 14″
R.J. Olsen is the nephew of Christina Olsen (of Andrew Wyeth's famous painting). R.J.'s lobster shack is packed with trapping equipment, ropes and buoys. The light from two windows and the doorway made this scene a challenge to paint. (There is a window behind the door.) I had to move from diffused lighting (at the left rear) to backlighting (in front of the window) to side lighting (behind and in front of the door), to a mixture of all three in the left foreground.

THE WEIGHING SHED, PORT CLYDE, MAINE, 10 × 14″
Port Clyde has all the boats and wharfs and lobster shacks you could ever want to paint. In this painting the outdoor area is the center of interest. The interior portion, though full of interesting shapes and colors, was kept muted. It's important in a painting like this to keep the values fairly uniform in the area of secondary interest. Value contrast attracts our attention like nothing else in a painting.

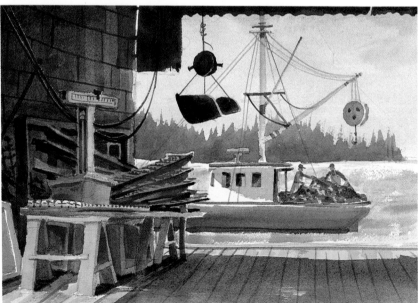

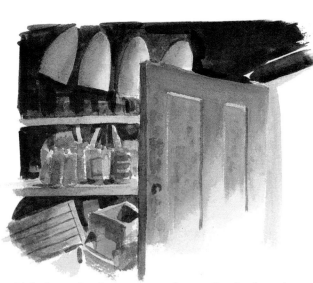

Objects that are backlit should be painted simply, with just enough detail to indicate form and subtle shadows.

Light is coming from two sources here, the doorway and a window behind the door. The light from the window is hitting the yellow buoys. On the door the tones of the shadows tell you where the light is coming from.

Backlighting makes dark silhouettes of the tin overhang and the scales. I mixed ultramarine blue and burnt umber to make a dark. While it was still damp, I added strokes of alizarin crimson to give warmth and life to the shadowed side.

There are multiple light sources here—the dock overhanging the water, the open side of the building, and a window behind the viewer—all affecting the shadow wash on the floor. I painted a mixture of raw sienna and raw umber across the whole floor. When it was dry, I added the shadow of burnt umber with a little ultramarine blue. The shadow wash is darkest where it contrasts with the sunlit portions of the floor.

CHAPTER SIX

LANDSCAPES— STEP BY STEP

I've been to quite a few workshops in my time and painted with quite a few well-known painters. Many of the best instructors are happy to do a lot of demonstration paintings. I remember the first time I saw John Pike do a painting in a class. I thought, "Oh, that's how you do that!" In my estimation, seeing a watercolor done in front of you makes everything clear. That's why I do so many of them in my classes and workshops.

Although a visual demonstration is probably one of the best ways to learn, make sure you use what you learn to develop your own style. I usually say to my beginning class, "Don't paint like me; paint the way you want to. But use my teachings and demos to help you paint better." Explore, be curious, be inquisitive, help yourself move forward in your own individual style of painting.

In this chapter, step-by-step demonstrations show the progress of five paintings from start to finish. These show my approach and my solutions to filling up that pristine white piece of watercolor paper. But remember, it's only one person's view, one person's solution. Use whatever you can from these demonstrations to help you plan and paint your own watercolors in your own individual style.

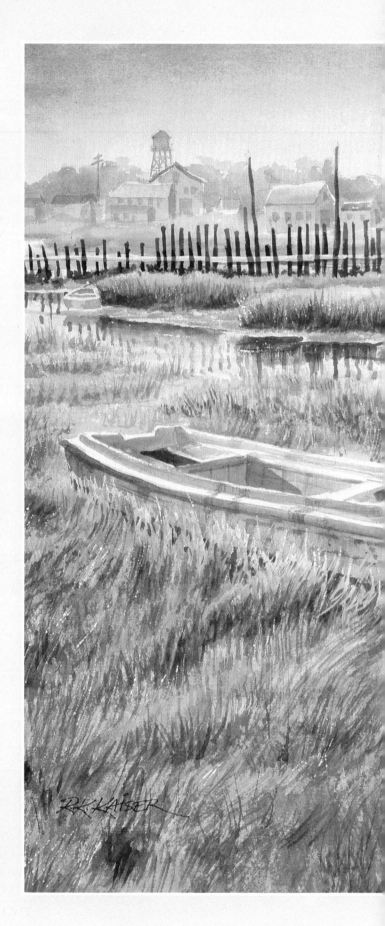

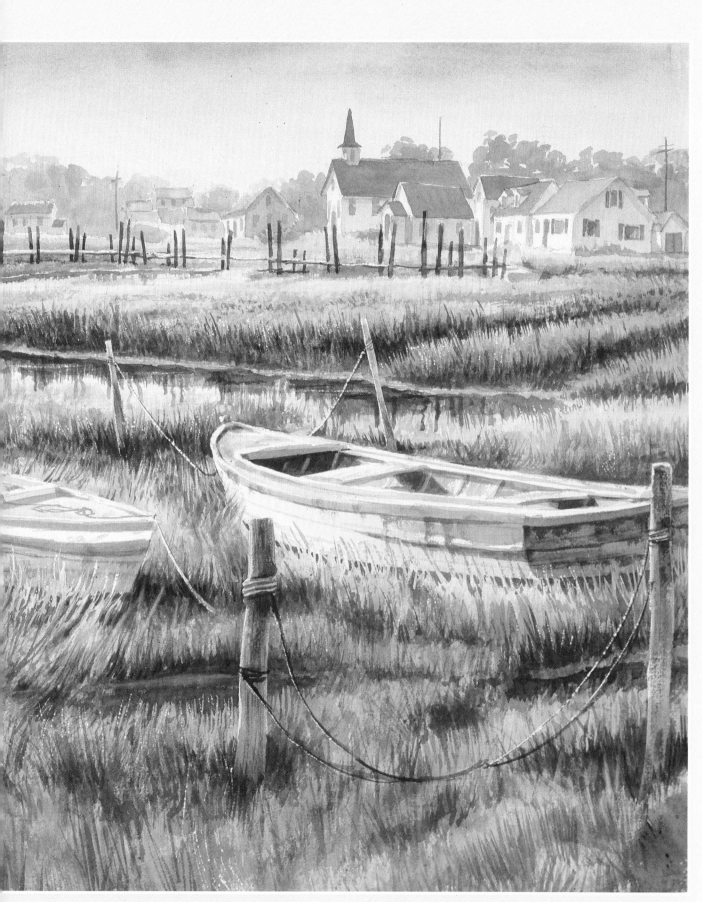

TWO BOATS IN MARSH WOODS, CHESAPEAKE BAY, 22 × 30″

PAINTING CAST SHADOWS

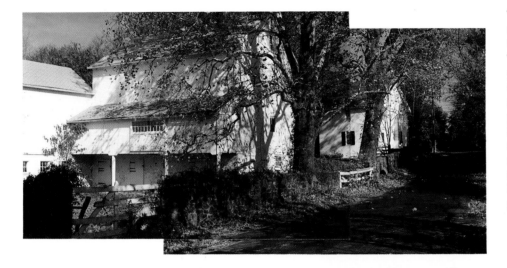

This is a panoramic photo of a farm near Washington's Crossing, Pennsylvania. The fall colors of reds and yellows plus the bright white of the house and barn make a colorful scene to paint. The cast shadows will have to be painted carefully, not only to show the form of the building, but also to trap the shapes of the yellow leaves on the trees, the ground and road.

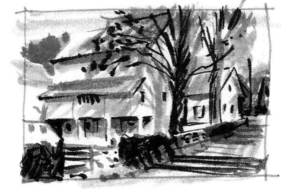

First, I did a quick thumbnail with my marker pens to establish my lights and darks and shadow patterns. The shadows need to be warm because the buildings are white and reflect a lot of yellow from the tree leaves.

Next, I did a larger pencil sketch—not too detailed, just emphasizing the big structures of the farm and indicating a little shadow and the darks of trees.

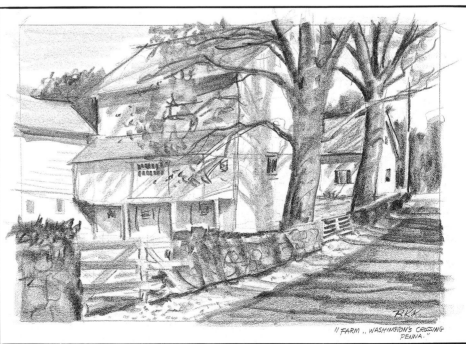

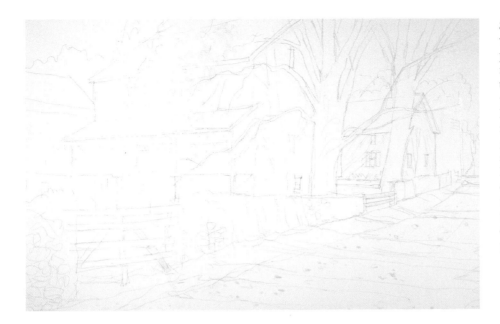

STEP ONE. Now, on to the watercolor paper. With a pencil I lightly outlined most of the shapes and details of the scene. I can always leave some things out later. I applied masking fluid to where the fence gate on the left is half in sunlight, where yellow leaves stand out in the shadows on the barn, and where the branches overlap other trees. Just for fun, I masked out the mailbox and telephone pole, too.

STEP TWO. For the sky I floated a wash of ultramarine blue, with just a touch of yellow ochre at the lower level to brighten it.

Next I mixed a wash of raw sienna, gamboge and cadmium orange for the fallen leaves near the stone wall. For the yellow leaves in the tree area I dabbed a mixture of gamboge and Winsor yellow over the frisket and leaves. While they were still wet, I touched the yellows with a little cadmium orange.

I painted the roofs with a gray made up of ultramarine blue and burnt sienna.

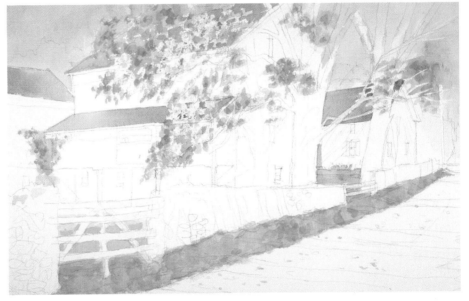

STEP THREE. I mixed a wash of Hooker's green dark and burnt sienna for the trees in the background. I used the green to trap some of the yellow leaves in the trees. I also added a little dark cast shadow to the tree by the house to show some depth.

For the road, I used a dark wash of ultramarine blue and burnt umber. I kept it darkest on the left side of the road where it dips downward toward the stone wall.

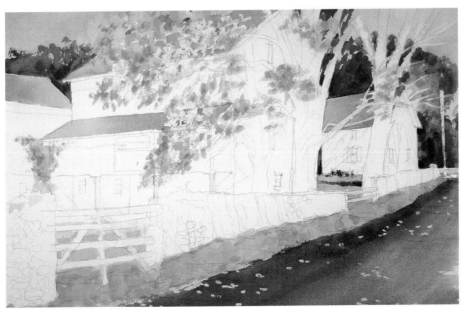

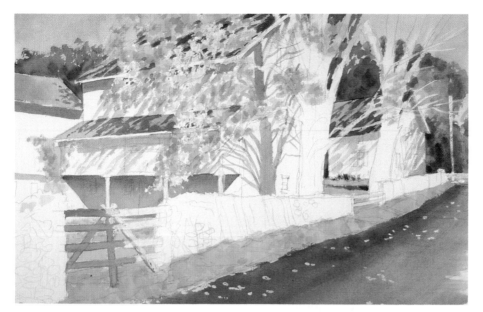

STEP FOUR. Now to the shadows on the house, barn and roof. I laid in a wash of ultramarine blue and a little burnt sienna under the eaves of the barn and house. I trapped the leaf shapes again, and stroked some cast shadows downward to indicate the shadows from the limbs and leaves. While it was wet, I added a touch of yellow ochre for warmth.

I darkened the same wash with a little more burnt sienna and added the cast shadows on the roof (again, around the yellow leaves).

STEP FIVE. Let's look at the stone wall and the cast shadows on the road, leaves and fence. I studied the source photo and my sketches to figure out where the shadows should fall. I laid a very light tone of burnt sienna (leaving a little white here and there) over the stone wall area. While this dried I mixed a dark wash of ultramarine blue and burnt umber for the road shadows. Starting on my right, I dragged a brush with this wash across the road, stopping the stroke when I reached the yellow-brown of the leaves.

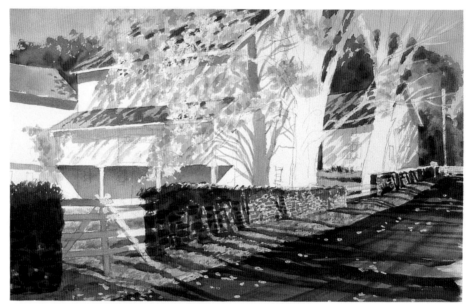

DETAIL.

Back to the stone wall now, I continued the dark blue-black wash on the side of the wall, indicating tree trunk shadows and foliage. Then, with a very dark wash of blue-black, I emphasized some individual stones in the wall. As you can see, I kept the stones light where they are exposed to the sun and darkened them in the shadow areas. I added a little ivy on top of the wall with a wash of alizarin crimson and phthalo green.

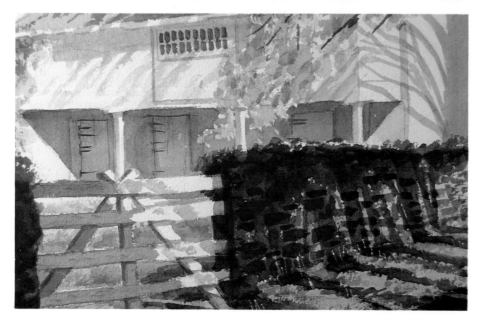

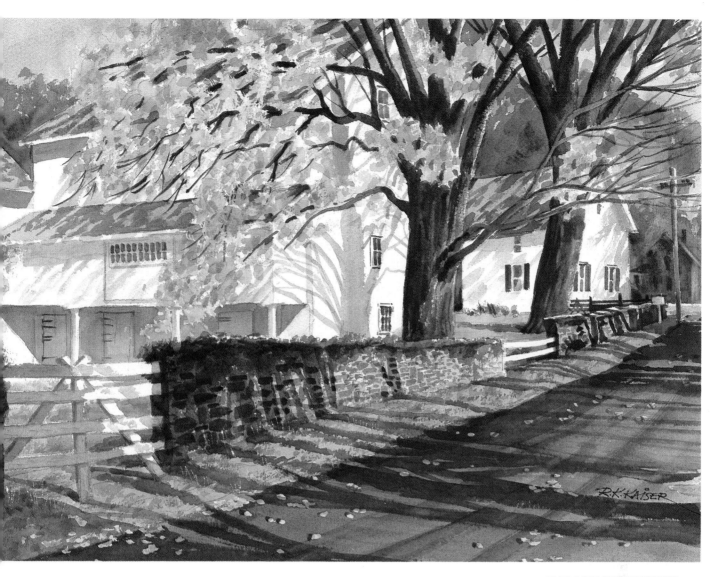

STEP SIX. Onward to the finish! I picked up all the masking fluid, except for the parts in the trees. I added the windows and shutters to the house, and also the doors and windows in the barn area.

With a mix of burnt umber and ultramarine blue for the tree trunk, I quickly washed a large midtone over the trees, with a bit more ultramarine blue to show the shadowed side. To paint the smaller branches in the foliage area where I had left the frisket, I dragged my rigger brush with dark brown paint directly over some of the foliage.

When the branches were dry, I picked up the rest of the frisket in the foliage area and added yellow-orange for the autumn leaves. I added a few more small touches, like the house beyond the telephone pole, to finish the painting.

FARM, WASHINGTON'S CROSSING, PENNSYLVANIA, 15 × 22″

SAVING SPARKLING WHITES

This photo of the gorge near Freedom, New Hampshire, was taken during a painting workshop. What a place to paint! As you can see, there were waterfalls just about every five feet, and each one was different. Notice all the colors in the rocks, too.

I tried to keep this thumbnail sketch simple and catch all the value patterns of the rocks and water. I think I started to fall in love with the scene, and I made it a little too detailed. Try to keep this kind of sketch as simple as possible, and aim for the big values.

In this more detailed pencil value study, I decided not to make the background too solid, and to show a little bit of sky and a couple of trees showing through at the upper right. I tried to keep a pattern in the flow of the water coming down from above. Working on the pencil drawing, I became aware of how much I had to simplify the rock area.

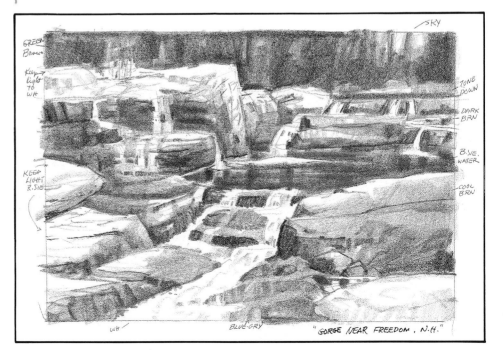

STEP ONE. This is the pencil sketch done on Arches 140-lb. rough watercolor paper. There were so many small waterfalls and rivulets (and some grass, too) that I decided to use masking fluid to preserve the whites instead of trying to trap around them.

STEP TWO. I used a mixture of burnt sienna and Hooker's green dark for the background trees. I left a little open area on the top right and added cerulean blue. Next I used mixtures of burnt sienna, raw umber, cerulean blue and cobalt blue in different values for the rocks, leaving chunks of white here and there. The higher rocks are much lighter to show areas bathed in sunlight.

After wetting the big waterfall areas, I added cerulean blue, keeping it light, so I wouldn't lose too much white.

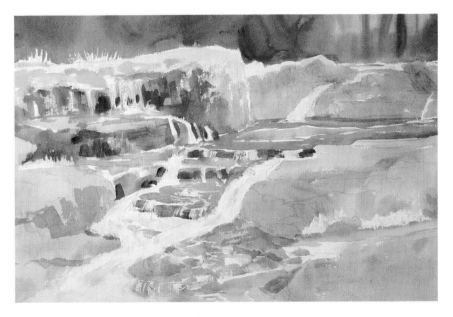

STEP THREE. I applied several washes of Hooker's green dark and a touch of phthalo green to burnt sienna for the distant trees. I left a little sky showing to provide depth of field and scratched out a few light tree trunks to give added interest.

I used washes of burnt umber, burnt sienna, raw umber and ultramarine blue to darken the rocks. I also added cerulean blue to cool down some of the warm browns in certain areas of the rocks.

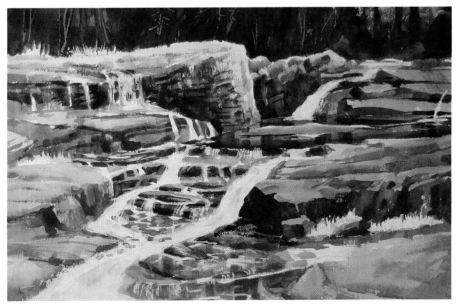

DETAIL.

STEP FOUR. I picked up the masking fluid and added touches of cerulean blue here and there, still trying to keep the falls mostly white.

I worked on the grasses and the reflections in the pool of water beneath the big rock. I kept the sandbar light, and when the water pool was dry, I dragged a drybrush stroke over the bar for texture.

As you can see in the detail at left, I went back with darker touches of browns and cleared up the edges of the rocks to make the water foaming down the face of some of the rocks stand out more.

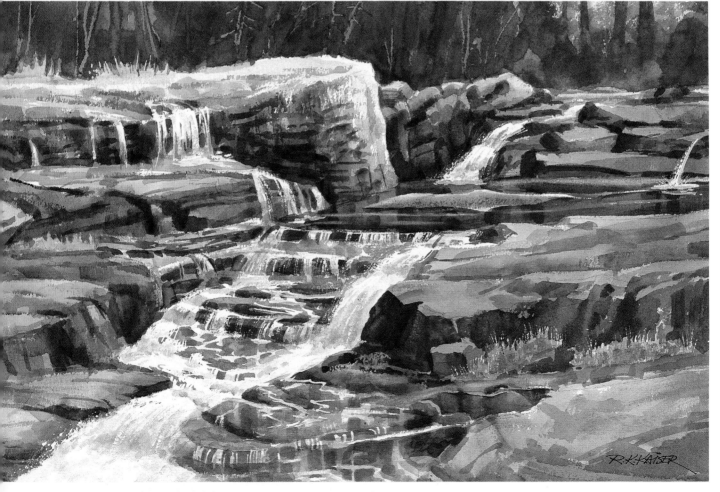

GORGE NEAR FREEDOM, NEW HAMPSHIRE, 22 × 15″

CREATING DEPTH

This street in Gloucester, Massachusetts, is typical of the area—hilly and twisty, just the kind of street Edward Hopper would have painted. Interesting structures, a curve to the road, and great shadows on the right make a pretty good scene.

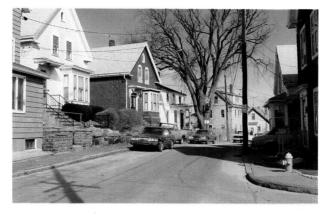

This little thumbnail suggested to me that I should do the painting as a vignette. I really punched up the right-hand shadows to catch your eye and the cast shadow to direct you visually into the picture. I needed to preserve a lot of whites and keep the colors under control.

The pencil halftone points up the architecture of the Gloucester area. I tried to keep the street open and free of tone to draw you into the picture. I've even added a walking figure to liven up the scene.

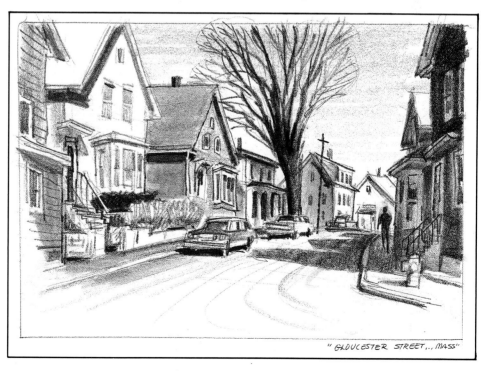

"GLOUCESTER STREET... MASS"

STEP ONE. For the sky I mixed a wash of ultramarine blue and a touch of burnt sienna and quickly flowed it over the sky area. I added a little wash of yellow ochre to the bottom of the sky to warm it up a little. While it was still wet, I touched it with a little cobalt violet here and there to add a little more color.

Next I mixed another wash of ultramarine blue and burnt sienna for the street. But this time I added more burnt sienna—see how warm it is? I did the sidewalks with a little more blue to cool them down and to add a little contrast.

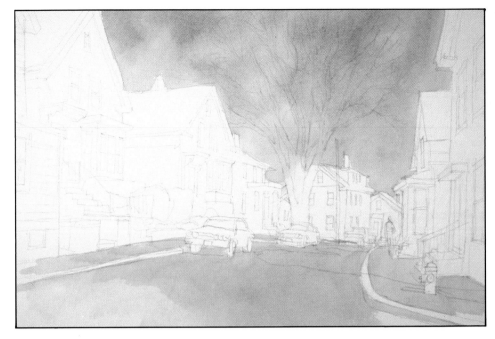

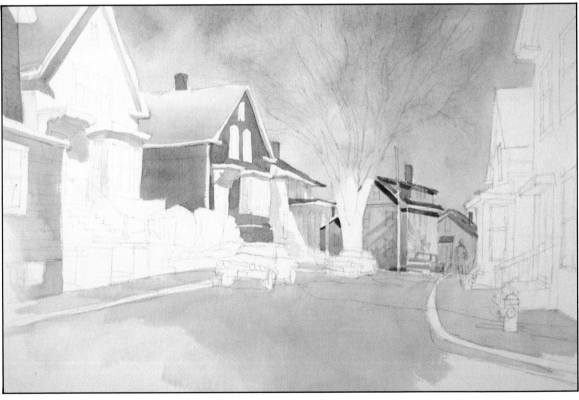

STEP TWO. For the houses on the left I started with a wash of Hooker's green dark and ultramarine blue for the green house. I faded it off on the bottom, vignette style, to match the fading off of the street.

I used ultramarine blue with warming touches of yellow for shadows on all the white buildings, while the roofs are a warm gray that fades from dark to light toward the roof peaks.

The red house is a light wash of cadmium red light. I couldn't resist adding a little dark to the far blue-gray building, just to see where a medium dark stood in relation to the other washes I'd done.

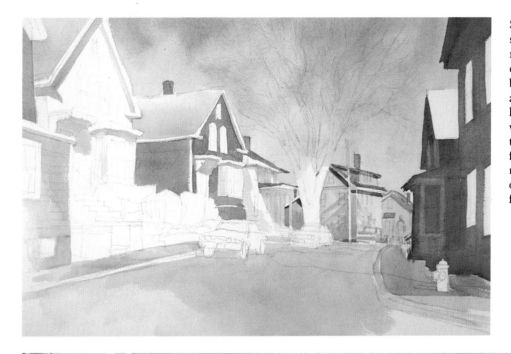

STEP THREE. For the shaded buildings on the right I flowed on a medium dark wash of ultramarine blue with burnt sienna and a little alizarin crimson, leaving some of the windows white. Later I'll darken these windows and show reflected light in them. I mixed a light brown wash on the sidewalk on the right for a warm touch.

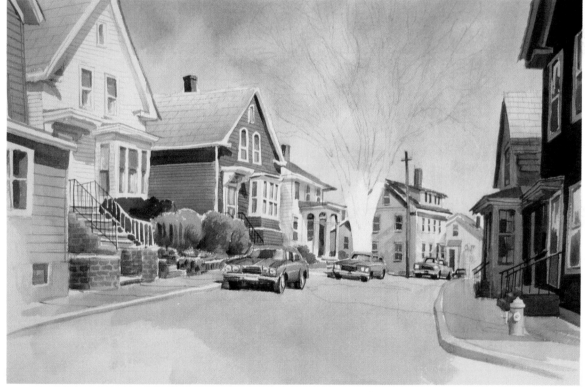

STEP FOUR. I mixed a gray-brown wash (ultramarine blue and burnt sienna) for the steps and stonework in front of the houses but kept spots of white here and there (such as the railing by the steps) to suggest bright sunlight. I kept the green shrubbery quite simple. These are accents that help set off the lightness of the building colors. I kept the cars and trucks simple, too, just suggesting their form and color.

The buildings are next. I went back and refined some of the washes, making them a little more detailed. I worked on the windows, darkening them here and there to show shades that were drawn halfway down and making sure that the sky was reflected (and shadows, too) in the windows on the right side.

I also darkened some of the shadows on the buildings to make them stand out more and added some line work to show clapboard, brick and shingles.

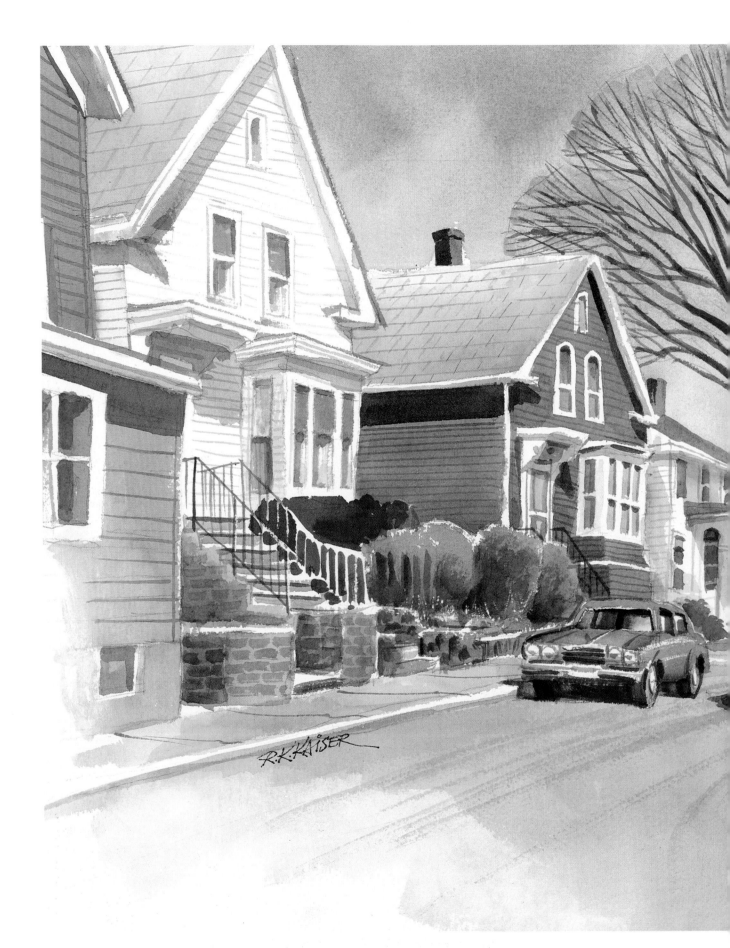

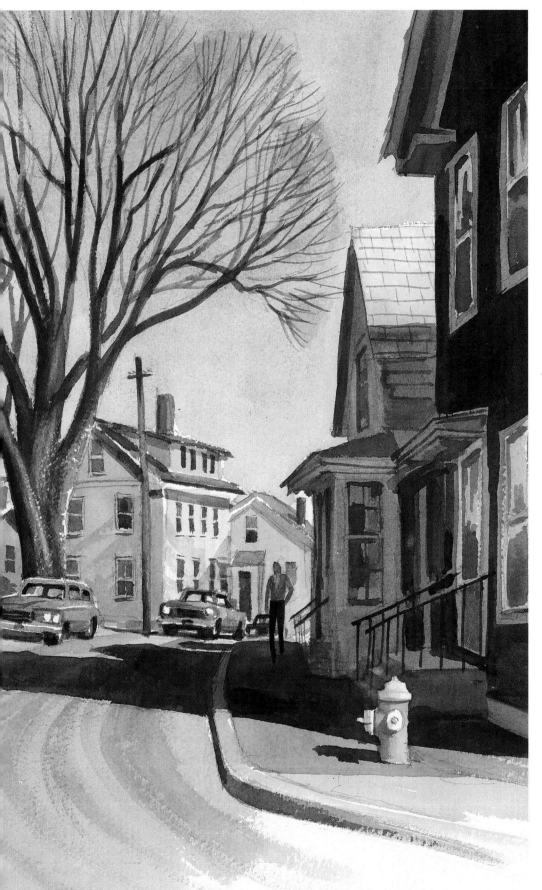

STEP FIVE. To finish, I mixed a wash of ultramarine blue and burnt sienna for the tree color and quickly brushed the brown on the big trunk area, trying to get a drybrush stroke on the side of the tree facing the sunlight. I formed the rest of the branches with a rigger brush. A light burnt sienna wash touched on with a flat brush added a little warmth and suggested a lot of very tiny branches.

For the shadow of the buildings on the street, I mixed a wash of dark ultramarine blue and burnt sienna again, and while it was wet, I floated a little alizarin crimson into it. I carefully trapped the color around the fireplug.

The figure came next. He not only adds some life to the painting, but he also gives an idea of perspective and height relationships. Finally, I added a few tire tracks to the street to draw you into the picture a little more and to give it that time-worn appearance.

GLOUCESTER STREET, MASSACHUSETTS, 15 × 22″

BRIGHT SUNLIGHT, DARK SHADOW

This little woodland scene with stream is representative of the Pocono Pines, Pennsylvania, area. Streaming sunlight, good cast shadows and silhouettes, and even a glimpse of another stream beyond the trees make a very good subject to paint.

I did this thumbnail sketch to solve the problem of light and dark shadows and values. I like the filtered shadow area on the right, and I've added a little more pebbled stone area to the foreground.

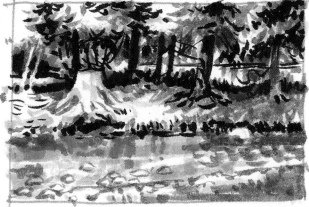

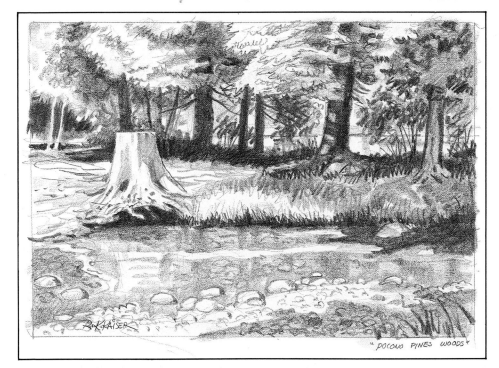

This more detailed pencil drawing shows more clearly the values that I wanted. I punched up some of the darks and added more interest to the foreground. I could see from this sketch that I would have to be careful when I rendered the trees; there was a lot of form to the bunches of leaves, the dark branches, and the trunks of the trees.

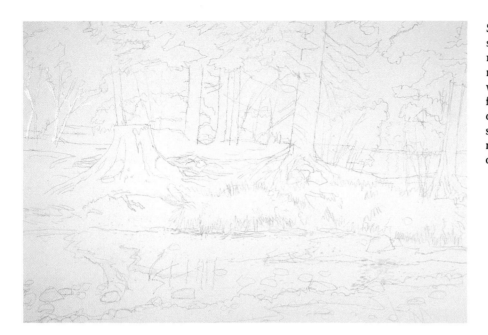

STEP ONE. I did my pencil sketch on Arches 140-lb. rough paper and added masking fluid to the parts I wanted to remain white: a few branches to the left, the descending roots of the stump, some of the grass near the water, and little dots of leaves in the water.

STEP TWO. I mixed a wash of Hooker's green dark and raw sienna plus a little burnt umber to make up the background yellow-green of the trees. I laid in a wash of burnt sienna for the stream in the background and floated a wash of Hooker's green dark into it. The foreground stream required another wash of burnt sienna, with some burnt umber at the edges where it meets the stones or grass. A very dark wash of burnt umber and ultramarine blue described the dark areas under the grass-lined bank and under the old stump.

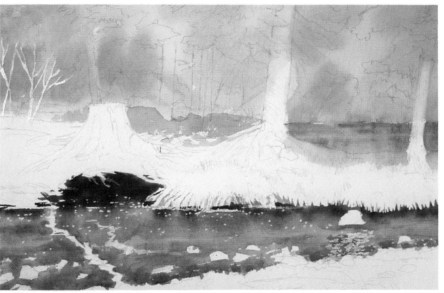

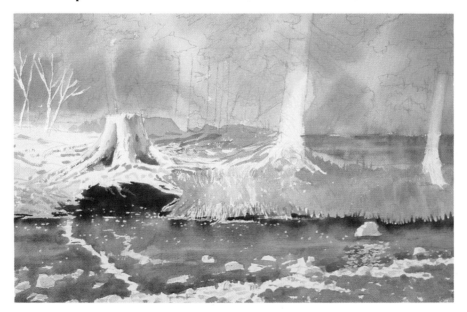

STEP THREE. Next, I mixed a wash of cerulean blue and raw umber with a touch of ultramarine blue to indicate the shadows of the stones and cast shadows from trees in the foreground (behind the viewer).

I used a light wash of burnt sienna and ultramarine blue for the shadow on the tree stump. It is light and warm from the reflected light of the ground.

Using raw sienna and Hooker's green dark for the grass, I left the area where the sunlight hits the grass a light yellow-green.

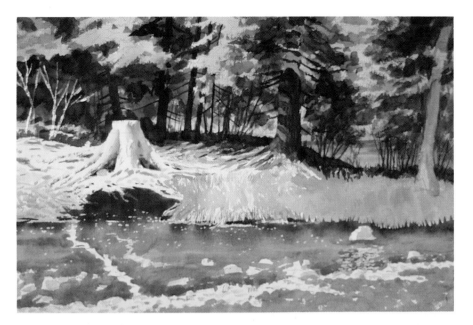

STEP FOUR. The darker greens of the dense foliage provide a cool, quiet contrast to the sunlit foreground. I mixed Hooker's green dark and cadmium red light for the medium greens, plus phthalo green and alizarin crimson to make the dark greens. Adding phthalo green and alizarin crimson made a very dark green. I worked from light green to medium green and then on to the very dark green, using the photo for a guide. I made sure you could see through the foliage to the other side of the stream.

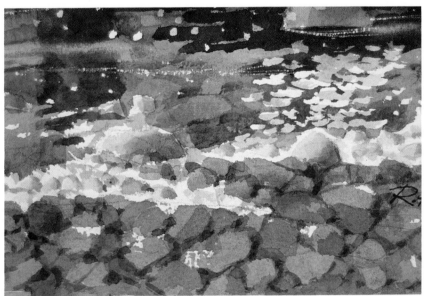

DETAIL.

I wanted to do more work on the stones in the foreground. I went back in and darkened certain stones on their shadowed side. With a brush and clean water I softened the darks by lightly scrubbing the side toward the sun, making them go light to dark.

I also added burnt sienna and light green to some of the rocks to add color and enliven the shadowed rocky area. Rocks are not all the same color.

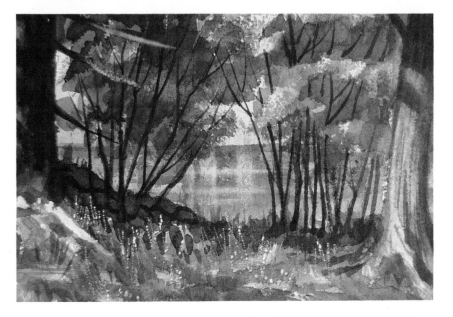

DETAIL.

To clarify the area of the stream in the background, I did a little more scratching with the razor blade and darkened some of the small trees and branches silhouetted against the stream. I also scrubbed out a reflected shine in the background water to make the viewer aware of water being there.

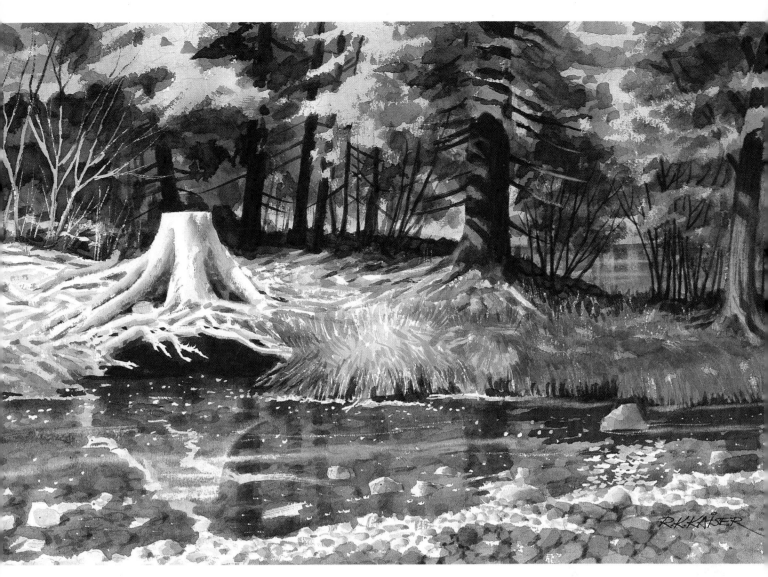

STEP FIVE. I picked up the rest of the masking fluid from the paper, leaving the whites. I mixed up a light green and a Hooker's green dark for the sunlit patch of grass and shadowy grass, respectively. I left some whites to show filtered sunlight coming through the trees and hitting the grass.

I defined the tree trunks with dark brown, then applied a wash of cerulean blue over the base of the large stump. When it was dry, I added washes of very dark brown, almost black, made of burnt umber and ultramarine blue.

Finally, I washed some burnt sienna over the trees silhouetted on the far left side and scratched out some branches. I also scratched some highlights in the grass area.

POCONO PINES WOODS, 15 × 22″

PAINTING VARIED TEXTURES

It was quite a cold day in Lenox, Massachusetts, when I found this area near the base of an old stone mill. I loved the stonework covered by the snow and thought it made a great value pattern. Combined with the water, overlapping dry weeds and bushes, the mill made a good painting subject.

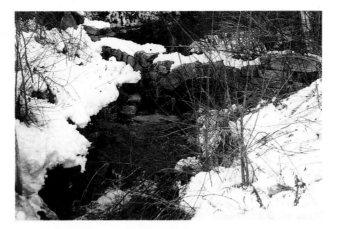

In my thumbnail sketch I left a lot of white and tried to keep it simple. The dark pattern against the snow looks almost like a leaning "T."

I learned from my pencil halftone to be aware of the darks and lights in the water.

"WALKING BRIDGE, LENOX, MASS."

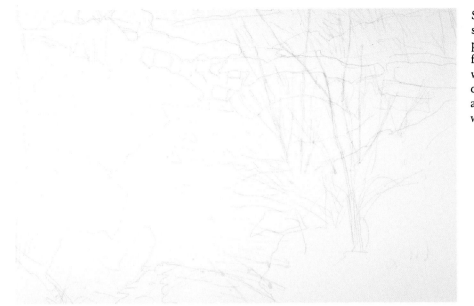

STEP ONE. I did my pencil sketch on the watercolor paper, then added masking fluid to the thin lines of the weeds, mostly where they cross the dark of the water and the dark of the stonework.

STEP TWO. I wet the top part of the painting, the bottom corners, and parts of the sides with clear water. I floated a mixture of ultramarine blue and burnt sienna into these areas while they were wet. They are quite soft-edged, as you see.

I darkened the same blue-gray wash and went over some of the stonework on the little bridge and some of the stones in the stream. While this was wet, I charged a little burnt sienna into the stones of the bridge to give it a mottled look.

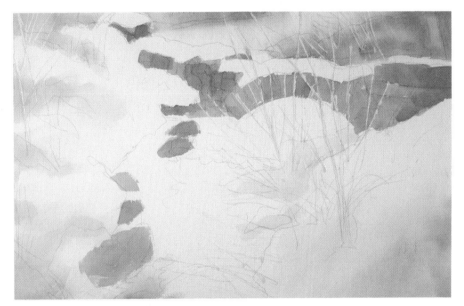

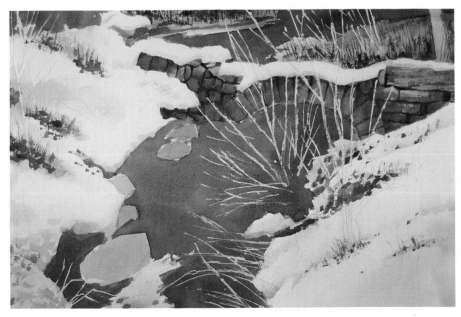

STEP THREE. I mixed a wash of ultramarine blue, burnt sienna and a touch of phthalo blue and covered the stream area. Next, I mixed some ultramarine blue and burnt sienna (more brown than blue) and laid my brush flat to the paper to show the ground poking through the snow. I dragged my brush upward to indicate some weeds.

I put a wash on the snow area behind the stone bridge to push it back in value to show distance, and darkened and modeled the stones.

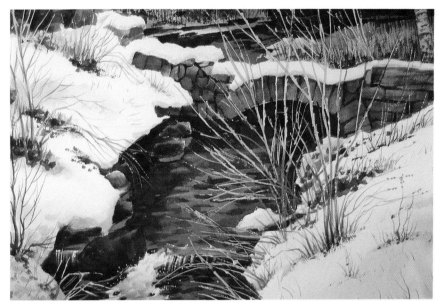

STEP FOUR. I mixed a darker version of the stream's blue and floated it close to the shore areas, keeping the center of the stream lighter. I kept the dark wash away from the white water, making it like a miniwaterfall. I darkened the area at the top of the painting where the snow lies beyond the bridge.

When the water area was dry, I lifted off the masking fluid and then added a light wash of raw umber to cover all the twigs that were white. I also added some drybrush weeds here and there. I took a razor blade and scratched some white flowing water over the edge of the tiny waterfall, and added some white drops of water next to the dark rocks and dark water.

STEP FIVE. For the final touch, I added bright vermilion leaves to some of the weeds. There are always some leaves hanging on, even in winter.

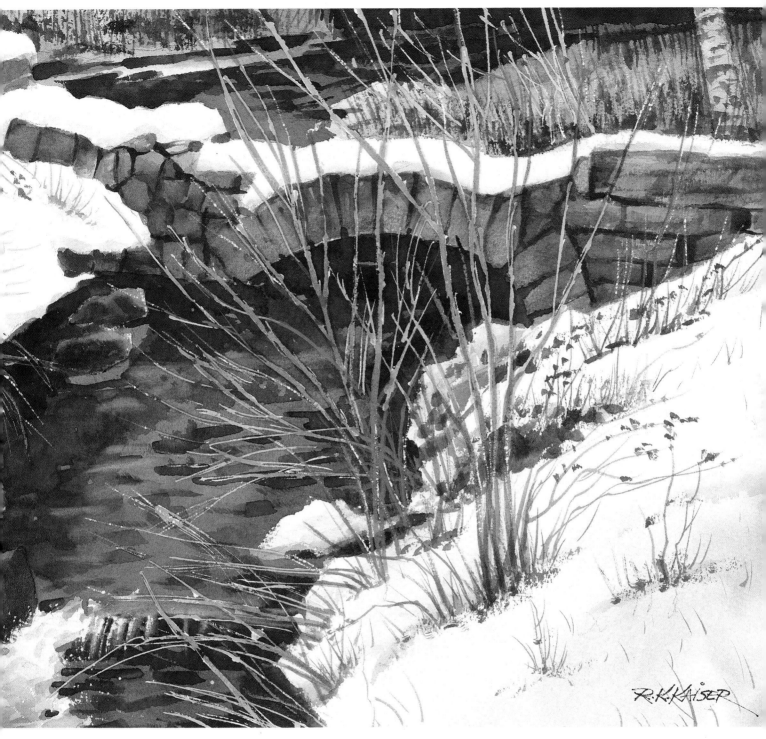

WALKING BRIDGE, LENOX, MASSACHUSETTS, *15 × 22"*
Collection of Mr. and Mrs. John Hawaka

CHAPTER SEVEN

IMPROVING YOUR PAINTING

When I'm asked, "Do you work only in your studio, or outdoors?" I always reply, "On location is better . . . but I know when to stop and bring it back home to finish." If you want to be an *outdoor* landscape painter, there is no substitute for painting outdoors. You see all the colors, feel the weather conditions, experience the smells, the sounds and the activity. But you also have to fight the elements, the moving sun, the weather, onlookers, not to mention our six-legged friends. Because the sun moves constantly, you can expect to spend approximately one to three hours in an outdoor painting session. Once you have captured the basic elements of the scene, stop. The changing light should tell you when to stop. With all its drawbacks, on-site painting gives the most reliable and truthful representation of your scene.

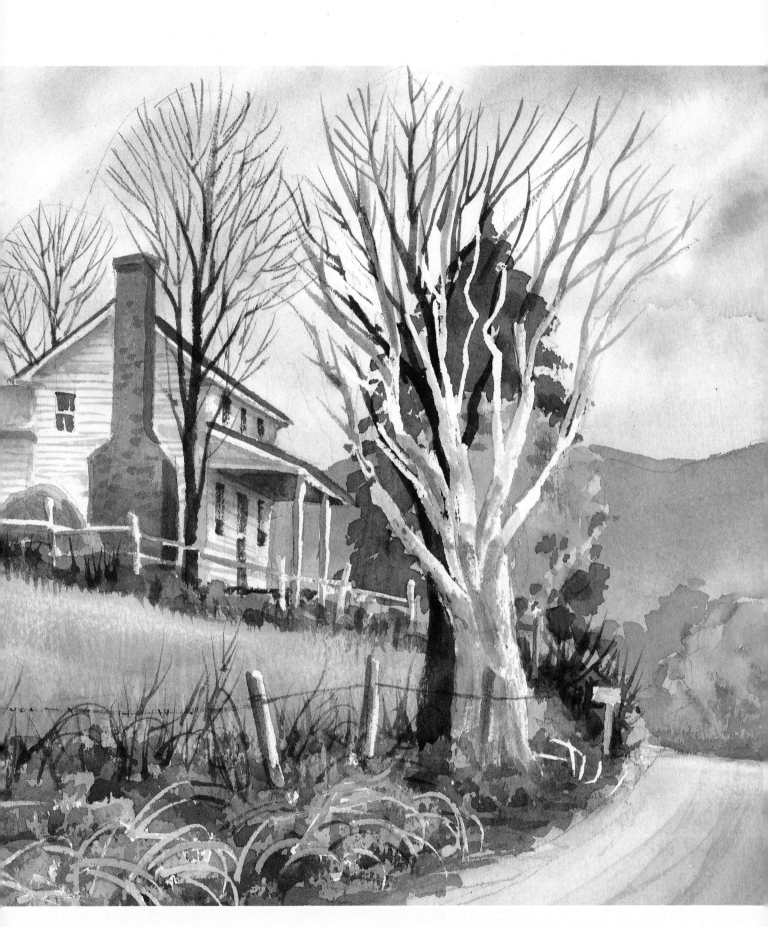

NEAR GREENBRIAR, WEST VIRGINIA, 10×14″

CRITIQUING YOUR WORK

Indoor or studio painting allows you more control and gives you time to evaluate your work. The light never moves, and the climate is always right. You avoid the outdoor changeability that so often ends in frustration. In fact, the studio is where your painting can come to fruition. Perhaps some time has elapsed since you started your painting outdoors, and now you can see it with a fresh eye, see how you want to proceed, possible mistakes you've made, or things you want to change.

Sometimes I stand a painting within sight in the back of my studio and look at it off and on for a few days, letting my subconscious review the painting. After some time has passed, I pick up the painting again. This process often helps me find answers to problems or gives me ideas on how to make the painting even better.

It's natural to want to improve your work, and a self-critique is a good place to start. But *don't* fall into the trap of trying over and over to improve one little detail, such as the shape of an

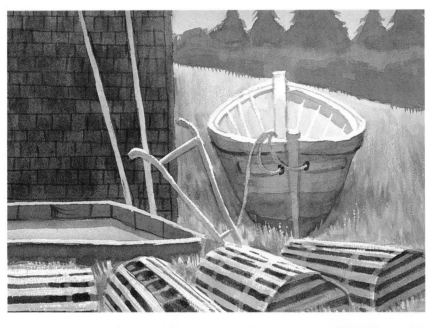

BAD. The dory, lobster pots and other island debris make this Monhegan Island scene a good subject. There's just one small thing wrong—the values are not done well. The building is much too dark and flat, which makes it too important in relation to the dory and the lobster pots. The background trees are too light to make the dory and the sunlit field stand out. The grass is also too light and is lost next to the dory shape. The dory almost blends in with the grass. It needs more definition.

GOOD. Look how small changes in value can improve the whole scene. The building is lighter and shows a little reflected sunlight toward the top. The dory and the field stand out much better, too. I've darkened the shadow area around the dory and suggested more detail in the grass. The shape of the dory—the main point of interest—is now important. The darkened trees not only make the field look brighter, but they also make the aft end of the boat really stand out.

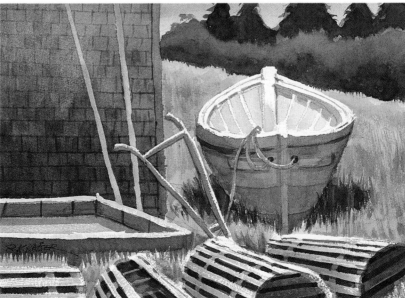

open gate. Though drawing is a key to good painting, the overall success of your painting will be determined by the whole picture, not the details. Check how your painting stacks up in these three areas: value relationships, color relationships and composition.

VALUE RELATIONSHIPS

As I've said so many times, values, values, values! This may be the single most important aspect of your paintings. Rather than worry about individual objects in your scene, you should concentrate on the dark and light masses. Base your overall design on the shapes of these areas. Only after

you've completed your planning should you work on the painting itself. However, it's only fair to warn you that sometimes, even with planning, the values may not look right as the work progresses.

To create depth, make sure you have achieved the proper relationships between the values. Values should pull the middle ground and foreground toward you and push the distance to the back. Again, concentrate on the major shapes in the scene and ignore the small details. The examples here show paintings in which the values weren't working properly and how I corrected them.

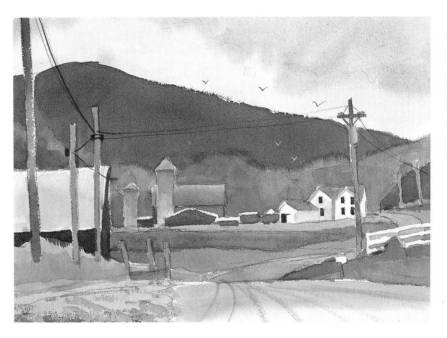

BAD. In this Vermont scene, the road does not seem to recede because the value blends in with the field. There is also too little contrast on the roofs of the barns in the distance and on the silos. The roof on the foreground barn is much too light for such a large area and has become too important. The mountain in the background is too dark and heavy. The trees in front of the mountain are light and offer no contrast to the small barns and houses. The house windows are too dark and draw too much attention.

GOOD. The same scene, and what a difference. Now the road recedes into the distance. The barn roofs stand out because I've made them much lighter (and a little more glowing) and darkened the trees behind them. Now your focus is on the barns and houses.

I've changed the field in value, too, alternating dark and light. Your eye can go back into the distance now. Darkening the roof on the barn on the left has made it less of a distraction. I lightened the windows on the houses, too, so they don't steal the show.

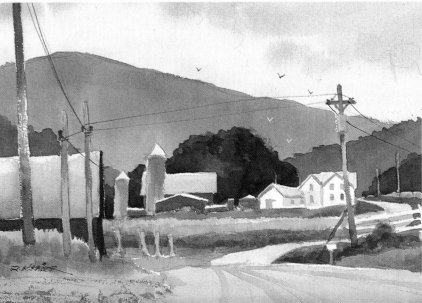

COLOR RELATIONSHIPS

Most students starting out in watercolor (or other mediums) have a tough time deciding how and when to use each color on their palette. I don't know how many times my students have asked me while I was painting a demo, "What color are you using?" Or, "What did you mix together to get that color?" I've since hand-lettered on my palette the names of the colors.

When a painting doesn't look right, and you've checked out your value relationships, try looking at the color relationships. There are many different ways to make color work in your paintings. Unfortunately, it is beyond the scope of this book to go into detail on this subject. A valuable book that covers the subject of color for the watercolorist in depth is *The Watercolorist's Complete Guide to Color* by Tom Hill.

One attribute you can check for is contrast of color temperature. A painting that is all warm colors or cool colors usually looks unbalanced and, maybe, a little boring. Try using a touch of warmth in a predominantly cool painting, or a touch of cool in a predominantly warm painting. See the example below.

COMPOSITION

Good composition in your paintings will help you tell a better "story" to your viewer. You might have heard that there are a lot of rules to composition—a lot of "dos" and "don'ts." Forget it. Many of the so-called rules can be bent and turned to open up to the artist all kinds of fresh possibilities.

Here are just a few comments about composition that might help you on your road to better painting.

• Try to create a dominant value interest. Ei-

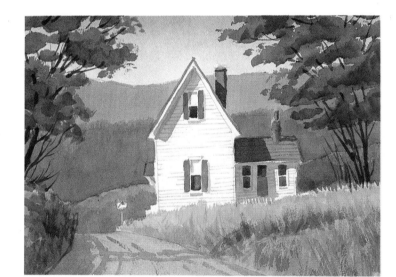

BAD. The color in this scene of Dorset, Vermont is uninteresting. Even the sky is bland and plain. Now, not all skies should be dramatic, as they might take away from the point of interest. But I think this one could be improved. Also, the trees could be more colorful and lively, as well as the grass and color of the road. It has all the workings of a good painting, but the color does nothing for the scene.

GOOD. My solution was to add more warm notes to this predominantly cool painting. I warmed the sky with a little cloud and a touch of yellow ochre. Yellow ochre on the grass makes it look more sunlit, doesn't it? Also, the road is warmed with a touch of yellow, as are the trees and the grass on the left. To give the roof a little more punch I added alizarin crimson, but I put a touch of bright vermilion to the left of the shadow to show reflected brightness.

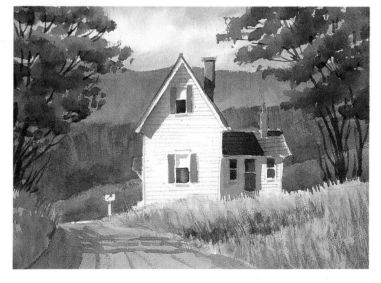

ther dark or light should predominate. Keep the middle tones as a "helper" to balance either the dark or light.

• Weight is a major compositional factor. Masses or objects should be balanced in relative size and position on a picture. If all the weight were on one side of the painting, it would visually tip toward that side and make the viewer uncomfortable.

• Avoid using objects that are too similar in size and shape in the same painting—mountains of the same height, trees of the same size, same-shaped rocks, or clouds, and so on. Stagger them, vary them in size and shape, and overlap them.

• Where is your center of interest? Each picture should have a center of interest or one thing that is the most important part of the painting.

All other areas of the painting should be subordinate to it.

• Directional lines or angles are great compositional tools. They help your viewer enter your painting visually.

• Be careful not to align two shapes so that their lines form a tangent. This can create an unintended shape that confuses the viewer or destroys the illusion of depth, as in the example below.

• Use any compositional device or technique that will help you show people what you want them to see. Move or change things so that the viewers will see more than just what's in front of them.

• Finally, as I've said so many times before, simplify.

BAD. This quick painting of a fisherman's house has some major compositional problems. The foreground fence blocks you from entering the scene. The one tall pole cuts the scene in half. The background trees meet the very tip of the red shack to the left of center. That's a "no-no." It creates an awkward tangent line that makes it appear as if the trees are at the same distance as the house. The low tree line makes everything seem to hug the buildings and the ground area.

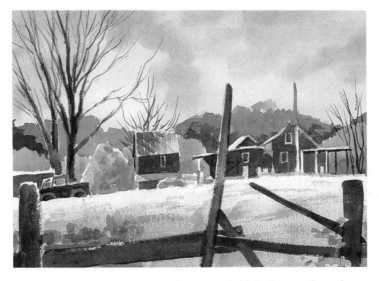

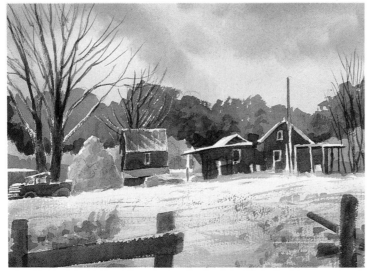

GOOD. I opened up the fence and led you into the scene with some ground rubble. I also raised the height of the trees to make a darker area of trees near the center. This accentuates the whiteness of the two roofs a little more. I scratched out a few branches behind the red shack on the left to add some sparkle to the scene.

CORRECTING TECHNIQUES

Let's say you've just come back to the studio from painting outdoors. You set your painting up on an easel and take a good look at it. You're satisfied, but there are a few things you think you could do to make it even better. These could be little things, or they could be major corrections. All is not lost. Somebody years ago described watercolor like this: "You put a stroke of paint on the paper and that's it, you can't change it, and that's why watercolor is so difficult!" That's enough to scare you, right? Today, we know there are many ways to "save" a watercolor painting.

Usually when my students ask me for help on their paintings, there's not too much wrong—just some little thing that could be done to make their paintings look finished. And they are often amazed at how little it takes to change what they thought was a complete disaster into a successful endeavor.

Of course, if your painting needs a lot of corrective work and extensive repair, it might be better to just stop and do it over. One of John Pike's students said, "Correcting a watercolor is like telling a lie. The more you try to fix it, the worse it gets!" This is certainly not always the case, but I think we have all had that experience at some time.

In the next few pages, I'll describe some helpful techniques you can use to make corrections in your paintings. We're going to explore cropping, glazing, scrubbing, misting, postcard cutouts, stipple brushwork, masking with tape and spattering. You will need a small mat board, a big brush, a man-made sponge, a spray bottle of water, old postcards, a stipple brush, masking tape (two inches wide), and a no. 6 oil painter's fan brush.

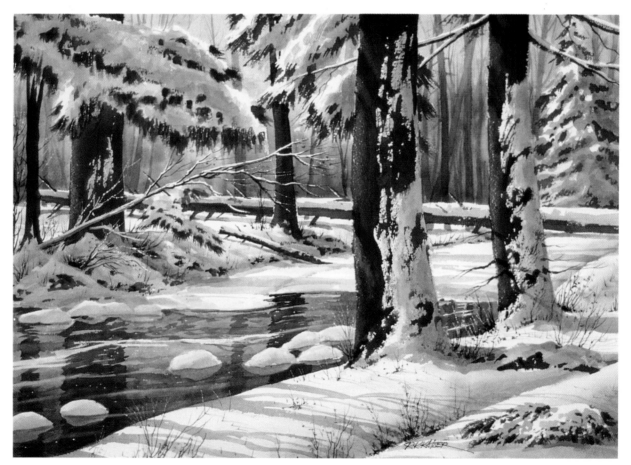

SNOW-BOUND STREAM,
22 × 30″

CROPPING

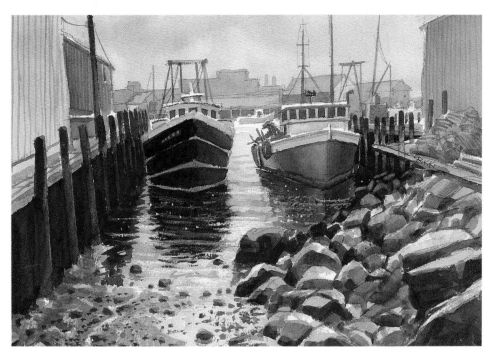

BEFORE. This is a typical scene around Gloucester, Massachusetts, rendered with a lot of the things you would see in the harbor: wharfs, boats, rocks, warehouses, etc. There is too much foreground showing, I think. It draws your interest away from the boats. This is where you should do some thoughtful cropping. If your point of interest is overpowered by things that surround it, you can remedy that by cropping.

With two *L*-shaped pieces of matboard, I tried a couple ways of cropping. At far left, I cropped in at the sides but left most of the foreground rocks showing. At near left, I cropped those rocks, making the format more horizontal.

AFTER. I chose the more horizontal format. Now the main center of interest—the boats—is readily apparent, and the whole scene is better balanced.

GLOUCESTER HARBOR,
10 × 14″

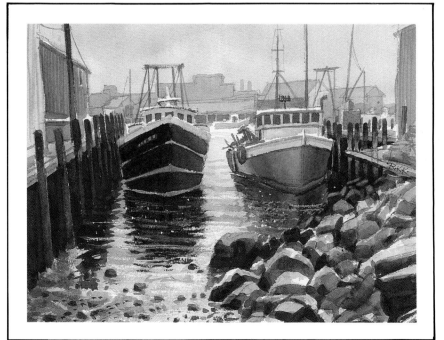

GLAZING

BEFORE. This painting is of a great friend of mine. He and I were painting on Nantucket Island. There is quite a lot of background in the painting. I tried to design it so that the figure would stand out as a vertical in front of all the horizontal lines. The problem here is that the values are too close. There are a lot of middle tones, and this needs to be changed. I can do this with a simple glaze—a layer of transparent color washed over other colors.

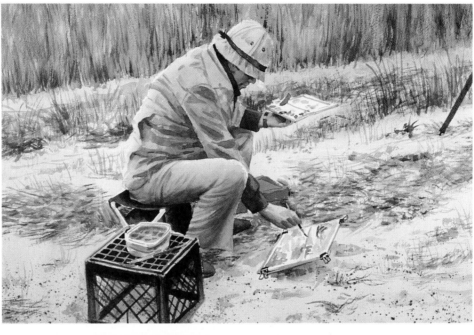

A darker wash of green pushes the grass to the background and makes the figure stand out.

(Far right) A darker wash for the dried seaweed focuses your attention on the artist's hand.

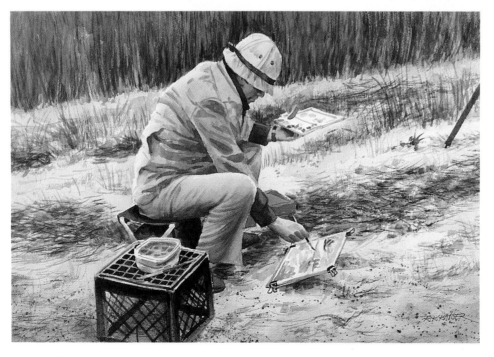

AFTER. Two simple changes made all the difference. The darker values not only punched up the background but also directed your attention to the figure.

H. MADSON. . .WORKIN' . . . NANTUCKET ISLAND, 15 × 22″ Collection of H. Madson, Elmhurst, Illinois

SCRUBBING

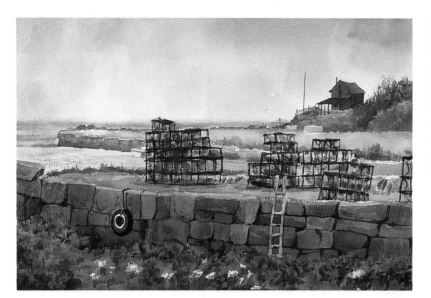

BEFORE. It was an overcast day and rain was threatening when I painted this scene at Lanesville Inlet, which is not too far from Rockport and Gloucester. When I returned to my studio, I felt something was not quite right. The focus was too sharp, and some areas were too dark.

I decided to soften the house on the point, as it had been an overcast day and the house should be a little out of focus. I took a damp sponge and scrubbed gently around the area of the house, then blotted up the color with a paper towel.

The top of the stone wall should be lightened to reflect a little more of the sky. Again I used a damp sponge, with a piece of paper to hold an edge, and scrubbed *away* from the paper.

I also decided to lighten some of the grassy area next to the stone wall to make it stand out and to direct your eye to the lobster pots and the faraway house by forming a visual line.

AFTER. Now the painting is more subdued and gives the feeling of an atmosphere heavy with moisture.

LANESVILLE INLET,
MASSACHUSETTS,
15 × 22″

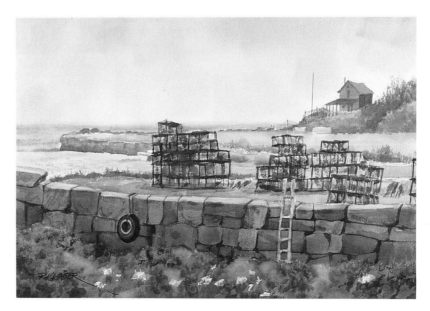

MISTING

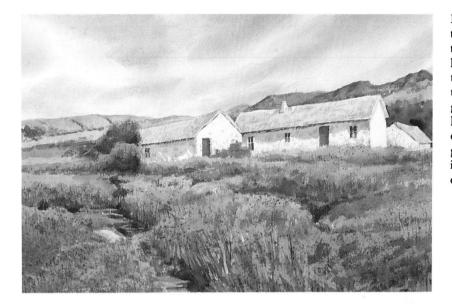

BEFORE. Lush green pastures, clear streams, thatched white stuccoed houses, all say "Ireland." I tried to capture the sky and the different colors of grasses surrounding these houses, but the sky turned out much too light, and the grass needs to be darkened in some places and lightened in others.

I grabbed my trusty spray bottle, set the nozzle on "mist," and lightly sprayed the sky area with clear water. The mist selection is soft enough to wet the paper without disturbing the paint underneath.

I could then flow more blue into the sky without making a hard edge.

In the same way, I misted the grass and added different greens.

To lighten parts of the grassy areas, I dampened the paint, then blotted with paper towels.

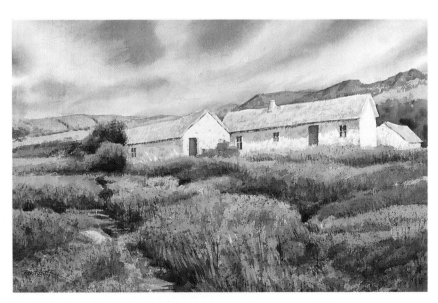

AFTER. The rich hues of the Irish countryside are now clearly seen.

PASTURES OF IRELAND, 15 × 22"

POSTCARD CUTOUTS

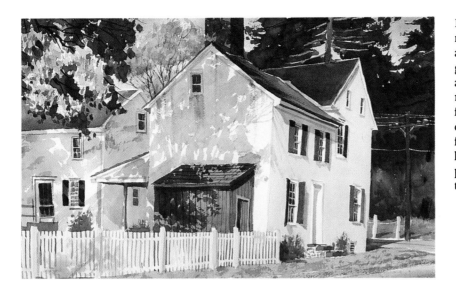

BEFORE. A crisp autumn morning, a historic house and slanted sunlight make a good subject. There are just a few things that need to be repaired. The roof on the far right top is much too dark, the side of the shed facing the sun needs to be lightened, and the telephone pole is lost against the dark trees.

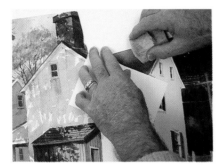

First I cut two small pieces of white cardboard and held them at an angle against the painting, masking out the roof outline. Then I scrubbed *away* from the cardboard with a damp sponge to lighten the roof.

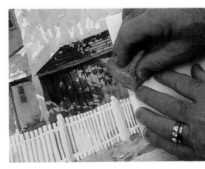

The wooden shed did not show enough definition where the sunlit side meets the slightly shaded side. I held a piece of cardboard right along that corner edge and scrubbed gently away from the cardboard.

The telephone pole was too dark against the dark fir trees. With two long pieces of cardboard, I scrubbed gently down the middle of the pole, keeping the edges darker.

AFTER. Anytime you're working with straight edges, sharp angles or corners, use postcard cutouts to help you lighten these areas without ruining your edges.

FALL AT WASHINGTON'S CROSSING, PENNSYLVANIA, 15 × 22″

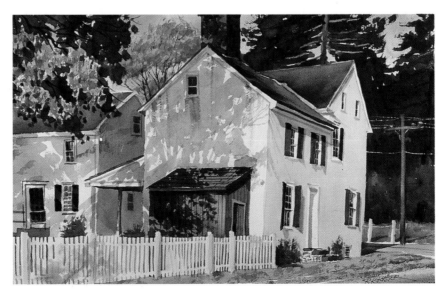

STIPPLE-BRUSH LIFTING

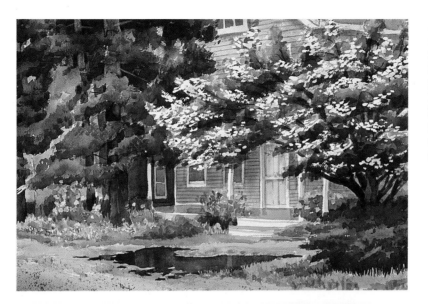

BEFORE. This small bungalow, located in Monmouth Junction where I live, presented several elements that attracted my eye. Everything seemed to be blossoming. It had just rained that night, and of course, I couldn't pass up the puddle.

I painted the dark trees and shrubbery and then saw that I got them a little too dark. With my stipple brush and some clear water, I carefully lifted out small areas of the foliage. By pressing lightly and blotting up the area immediately, I was able to pick up just enough of the unwanted paint.

The puddle also needed some lifting out to show reflections. The stipple brush used on its edge gave me thin, light, white lines. When applied flat, the brush will lift out larger areas.

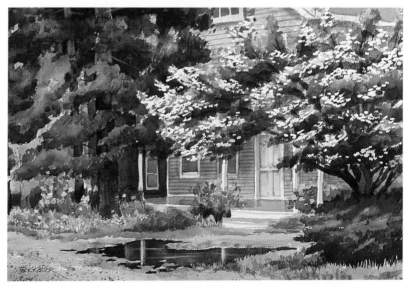

AFTER. A stipple brush is ideal for lifting out reflections in water because it produces soft, feathered edges, as you can see in the puddle.

HOUSE ON THE CORNER, MONMOUTH JUNCTION, NEW JERSEY, 15 × 22″

TAPE AND SPATTER

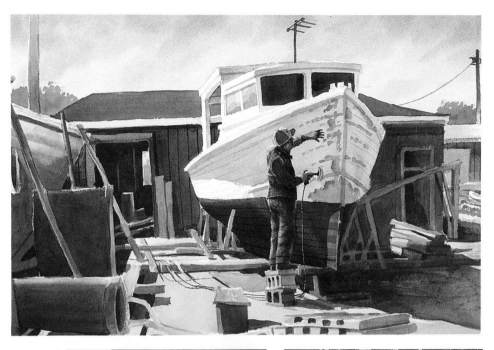

BEFORE. This picturesque shipyard in Crisfield, Maryland, was a very busy place with all kinds of objects lying around. Although I was basically satisfied with the painting, it seemed too neat and tidy. I decided that some spatter would make the foreground more interesting.

After taping around the roof and covering the boat, I used a soft sponge and clear water to lightly scrub away some of the too-dark blue roof. Then I covered parts of the foreground with tape and did some spatter work with my no. 6 fan brush to show more texture.

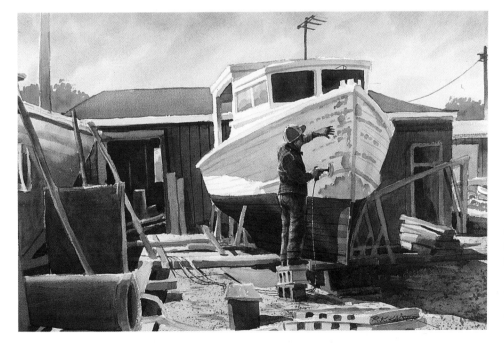

AFTER. Now it looks a lot more like a real working shipyard.

WORKDAY AT CRISFIELD, MARYLAND, 15×22″

PRACTICE SCENES AND STUDIES

Here are a few photos and some of my pencil studies to give you some helpful "homework." First, do a small, quick wash or pencil value sketch of the scene to get you started. Then go on to your painting on full-sized paper. You don't have to copy or follow these scenes exactly. Move things around to your liking. The black-and-white sketches on pages 116-117 will give you an opportunity to visualize your own color scheme, though I've made some notes in the margins. It's up to you, as the artist, to add your own outlook. Remember, keep it simple and have fun.

LAMBERTVILLE CANAL, NEW JERSEY

Isn't this a paintable scene? The white bridge, the red building and the tree make a great center of interest. The overlapping buildings help direct your eye to the background. Keep them simple. The building on the right with the shrubs breaking into it is another shape that directs you to look down the canal. Notice that little bit of sparkling white to the right of the tree? I'd emphasize that a little more. Always leave more white than you need. It will make your paintings sing.

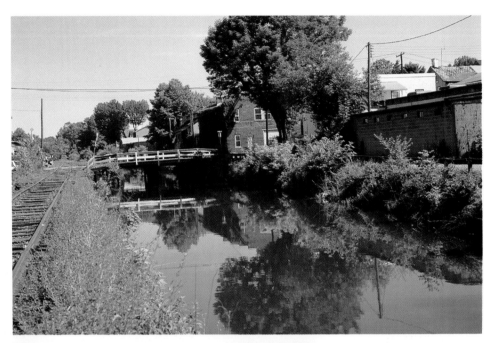

WASHINGTON'S CROSSING, PENNSYLVANIA

Here's a nice rainy-day scene. It even has a great puddle! Keep the large tree dark to silhouette the house. I would crop in a little from the bottom—there's too big an expanse of street. Notice how the house is reflected not only in the large puddle but the smaller ones, too. I would leave out the stop sign and subdue the building and trees on the right. The house on the left is really the main point of interest. Keep the sky simple: gray-blue, dark to light toward the housetops.

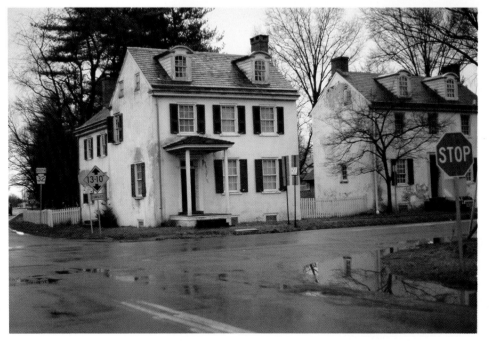

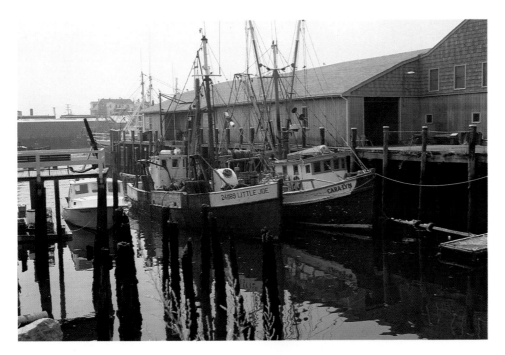

GLOUCESTER BOATS
This busy waterfront scene needs to be simplified. I would keep just a few pilings in the front. I would also eliminate the dock that's in front of the small white boat.

Keep the background buildings a soft silhouette. They work well with the general composition. The darks form a big triangle pointing to the left. Keep the highlight of the orange lifeboat in to make that area sing.

Keep the reflections dark and simple, with only a little of the white from the boats.

PORT CLYDE HARBOR
A good scene, but edit some of the useless detail out. Crop a lot off the bottom, but keep part of the water. You could move the telephone pole and lumber pile closer to the red lobster shack and simplify the buildings on the right, too. The trees are a great background, dark enough to make the buildings stand out. Keep some of the foreground water to make use of the reflections. Notice how it reflects the bright blue of the sky. You can paint the exposed ground with lots of texture to contrast with the smooth reflective water.

WAYSIDE INN GRIST MILL, SUDBURY, MASSACHUSETTS

Keep the snow in the light area pure white. The shadows on the snow could be a soft blue-gray. The stone building is light tan and burnt sienna. The background is soft, dark, blue-gray. Just suggest the trees in the background areas.

Be careful with the values in your painting. I've done this pencil sketch quite carefully to develop the values.

FARM, OLD MISSION PENINSULA, MICHIGAN

Keep the sky on the bright side. Make some white fluffy clouds and angle them toward the top right. Darken some of the sky around the roof edges. The tin roof can be suggested with just a few streaks of cerulean blue and should be kept rather light.

The dark green trees will help to accentuate the barn while the shadow from the barn on the right helps to hold the barn to the hill. Work on the grassy hills with big washes first, and then make the grass and the weeds quite detailed. Just don't take away interest from the barn.

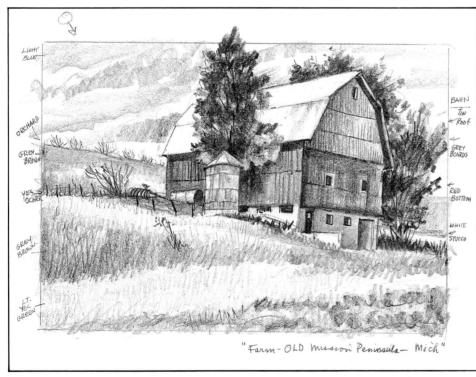

PEMAQUID LIGHT, MAINE

Here you can make the top (the sky) or the bottom (the rocks) as detailed as you like. The lighthouse should be able to stand on its own. Darken the sky a little around the white light-house to make the light-house stand out more. The sky could be done with ultramarine blue. The rock color is on the warm tan side. The picket fence, the grasses and the dark green of the trees on the right help to add other colors to the scene.

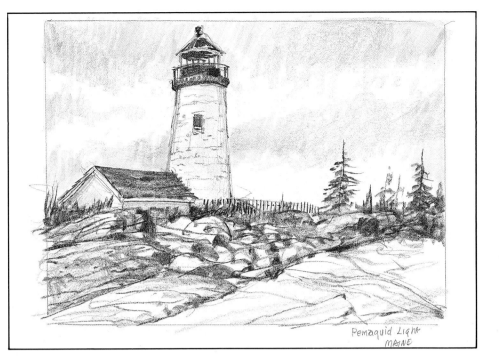

Pemaquid Light
MAINE

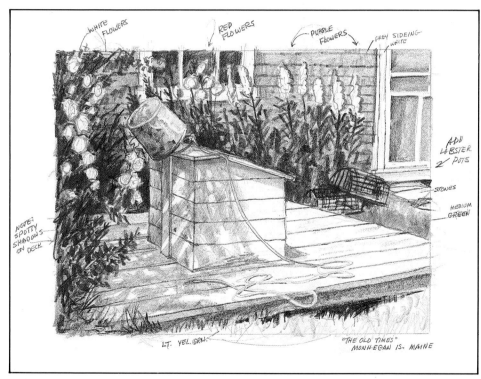

WHITE FLOWERS

RED FLOWERS

PURPLE FLOWERS

GREY SIDEING WHITE

ADD LOBSTER 2 POTS

STONES

MEDIUM GREEN

NOTE: SPOTTY SHADOWS ON DECK

LT. YEL. GRN.

"THE OLD TIMES" MONHEGAN IS. MAINE

THE OLD TIMES, MON-HEGAN ISLAND, MAINE

In this scene, paint the flowers first, leaving the flowers on the left white and painting the flowers in the back with bright colors. Do these colors first, then paint around them with all the other colors.

The floorboards and the well cover are white. Make your cast shadows on these a soft blue-gray. The dark green of the foliage makes the well cover stand out nicely. The foreground grass of light yellow-green will give the feeling of sunlight. Have fun with this one. Keep it light and "painterly."

CHAPTER EIGHT

PAINTING IN DIVERSE SETTINGS

Every setting or locale has its own way of captivating you and making you want to paint it. The mountains, the forest or the quaint Victorian house may call to you, "Paint me, paint me." Sometimes we go back to the same area again and again and see the scene as if we've never seen it before. Every time I return to Rockport and Gloucester in Massachusetts I find something new to capture my attention.

Make a point of visiting and observing as many different locales as possible. Look for painting subjects wherever you travel. Take photos, do sketches, or best of all, bring your paint box and set up right there in the forest or on top of that mountain.

Remember to carefully observe and plan before you put paint to paper. Each locale is different, but the painting problems you have to solve will be similar. Ask yourself, What should I leave out of the painting? What can I simplify? Can I move things around or overlap them to make the painting better? And don't forget to put yourself into your painting. What emotion do you want to put across?

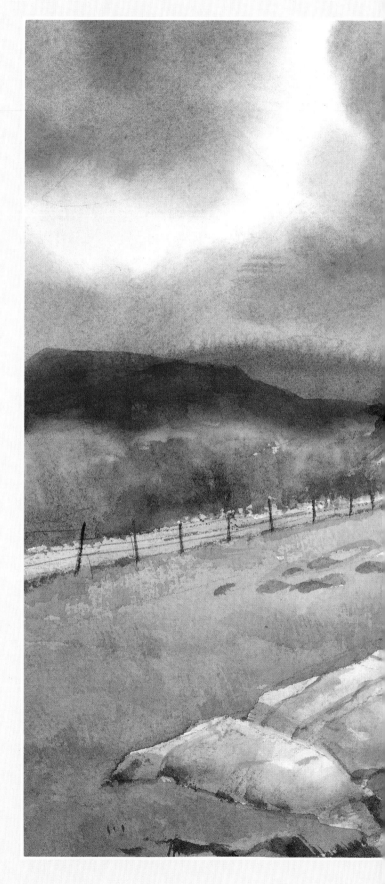

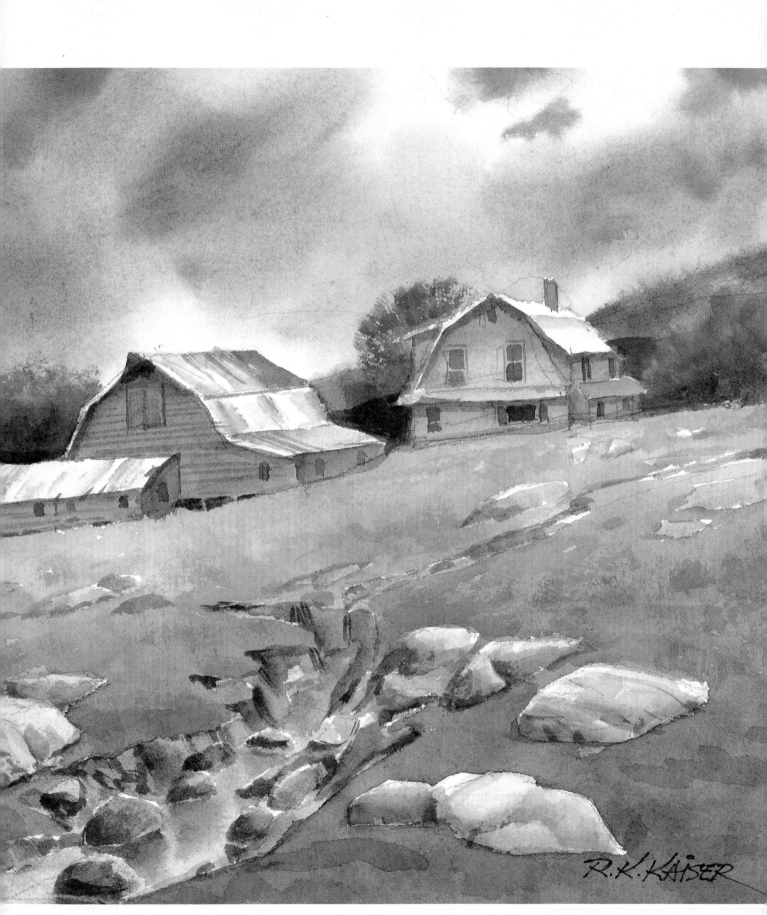

TOP OF THE HILL, 10 × 14″

BY THE SEA

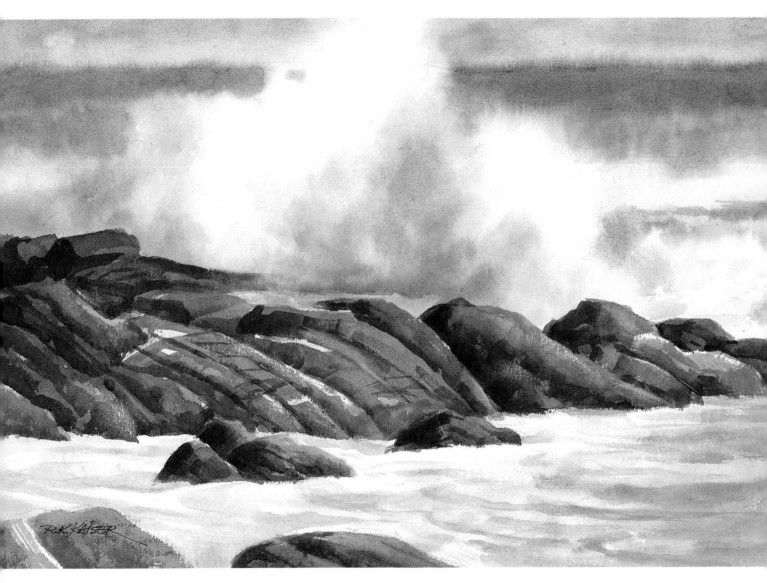

ROCKS NEAR ROCK-PORT, MASSACHU-SETTS, 15 × 22"
The ocean hitting the rocks around this coastal town has been the subject of hundreds of paintings over the years. You could stand here for hours and no wave would be the same as any other. I've discovered, through hours of observation, that every seventh wave is often an unusually big one.

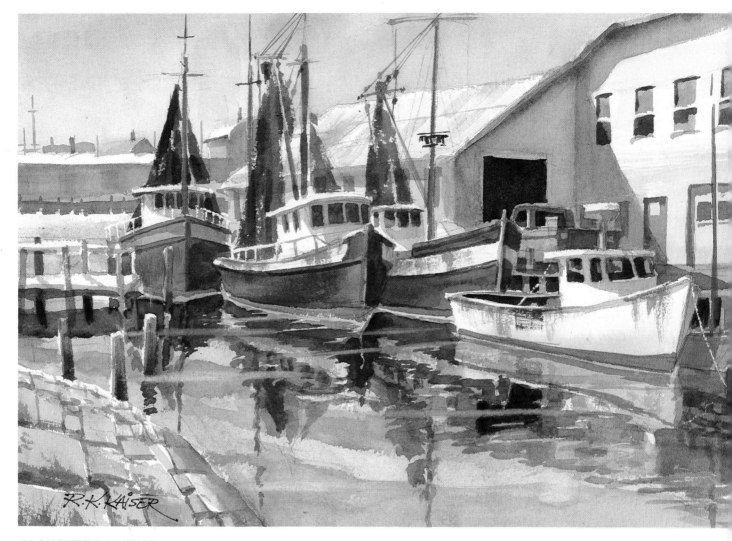

GLOUCESTER HARBOR,
10 × 14″
A wealth of painting possibilities awaits you in Gloucester. Just bring plenty of paper and paints and, oh yes, lots of film for your camera. The boats pictured here are all working boats—not too pretty, but their rugged sturdiness and their warmth make them eminently paintable.

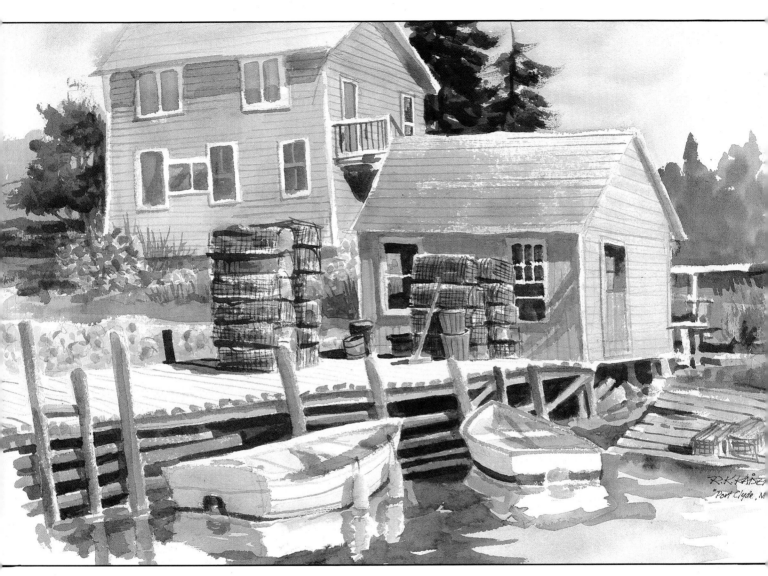

**WHARF AT PORT CLYDE,
MAINE, 15 × 22"**
Here's another harbor
scene, but a much more
tranquil one. Most of this
cool temperature painting
is done in cool blues and
greens, yet warmth is sug-
gested with a few touches of
red that enliven the scene.
This is also a vignette, which
makes it a little different
from the usual harborside
painting.

COOL FOREST STREAMS

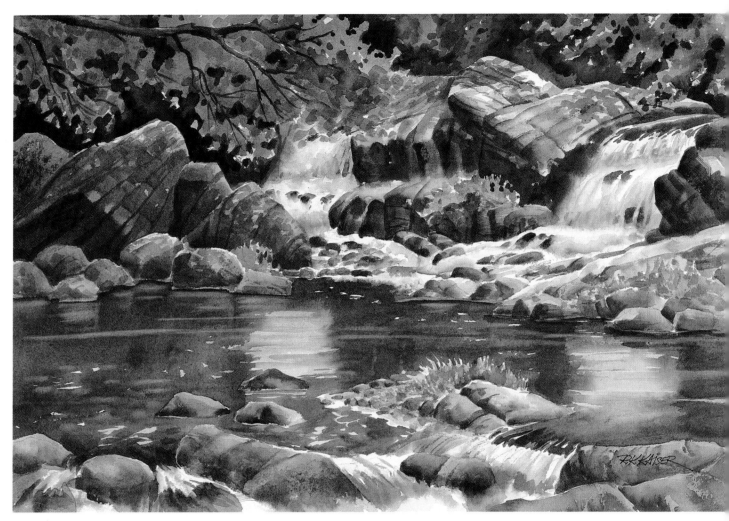

STREAM, PISGAH
MOUNTAINS, NORTH
CAROLINA, 15 × 22″
When painting this kind of
scene, try to focus on one
part of the stream. You may
need to move a tree or rock,
reduce something or make
something bigger. The trees
in the background can just
be a mottled dark—it still
gets across the idea of trees.
When painting rushing wa-
ter and waterfalls, remem-
ber to leave more white on
the paper than you think
you'll need, even in a cool,
low-key painting such as
this one. You can always go
back in later and darken the
water to show form and ac-
tion.

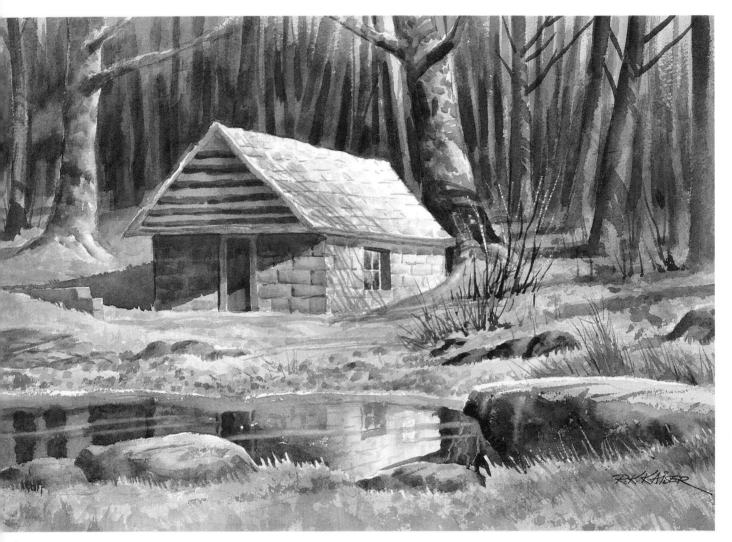

SPRING HOUSE, PENN-
SYLVANIA, 15×22″
Farms in many areas of the
United States have old
spring houses where farm-
ers used to store their milk
and meat. Most are recessed
into the ground with a few
steps leading down to the
doorway. They're made of
fieldstone, brick, or even
logs and concrete blocks,
like this one, and are nor-
mally found next to a
stream or spring. The
farmer directed part of the
stream through the spring
house into a cistern or ce-
ment holding trough,
where he would store his
cans of milk to keep them
cool.

Notice how the cast
shadows on the spring
house show the form of the
concrete blocks, the roof
and the logs. Let shadows
help form the objects you're
painting.

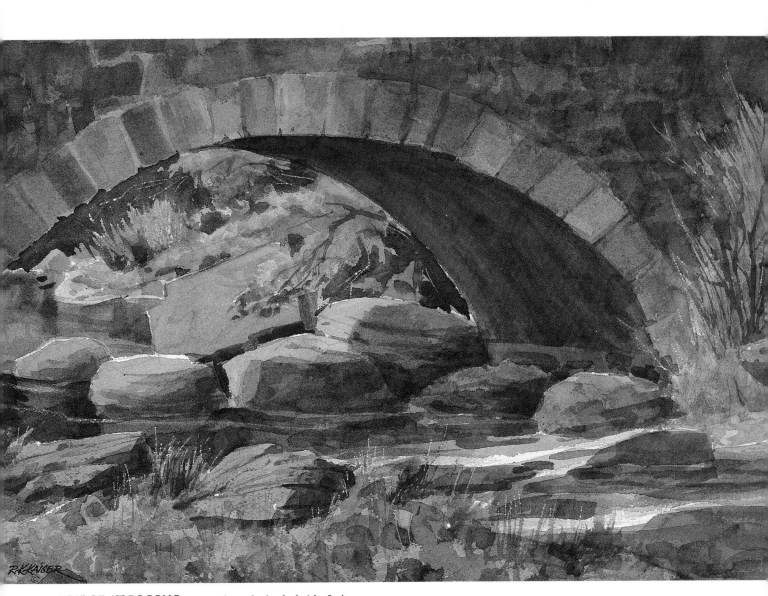

BRIDGE AT POCONO PINES, PENNSYLVANIA, 15 × 22″

This old stone bridge has been painted and photographed many times. My goal was to view it from a different angle. I decided to show just part of the stonework and more of the stream and rocks underneath the bridge. The broad, shaded side facing me made the lighting a bit of a challenge, so I decided to backlight it with warm colors reflected off the grass area. Here again, shadows can help show form. See how the edge of the bridge shadow hits the sunlit rocks and tells you exactly what shape the rocks are.

AROUND TOWN

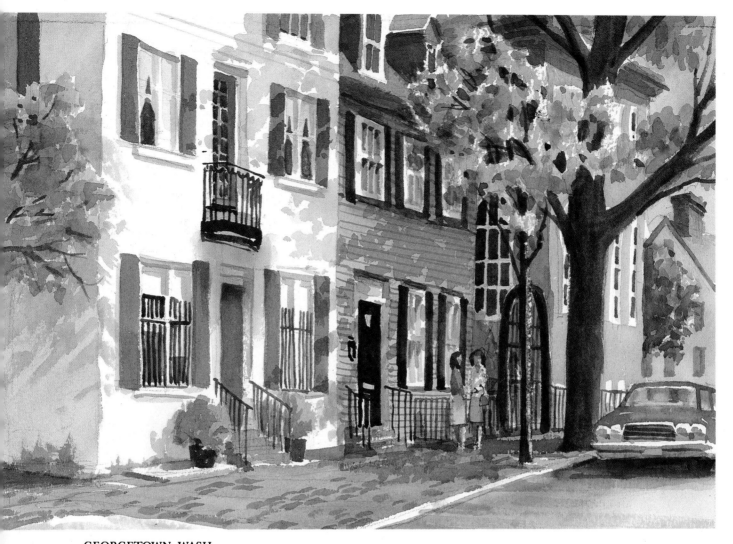

GEORGETOWN, WASH-
INGTON, D.C., 10 × 14″
The patterns, shapes and
perspective all say "city."
Each house in almost every
block of Georgetown has
unique architectural fea-
tures. The shadows thrown
by the trees and buildings
help to show form and per-
spective and guide your eye
down the street.

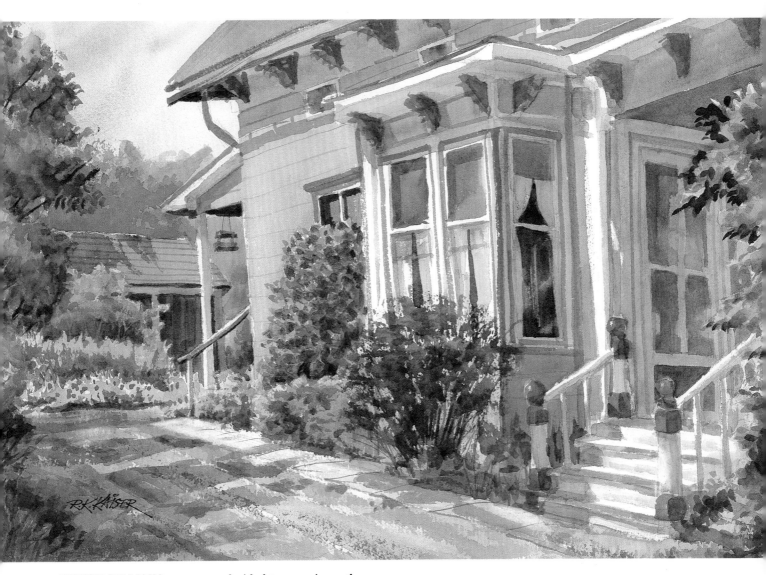

HOUSE ON MAIN STREET, FREEHOLD, NEW YORK, 15 × 22″
This picturesque house with its colorful gardens and interesting cast shadows just asked to be painted. Surveying the scene, I realized I could do a painting of the whole house, the driveway and the trees surrounding it. But I decided to zoom in on the back of the house. When painting scenes around towns or cities, use overlapping shots of several houses along a street or, as I've done here, concentrate on a single house and suggest other houses nearby by showing a roof or some chimneys in the distance.

MOUNTAIN VISTAS

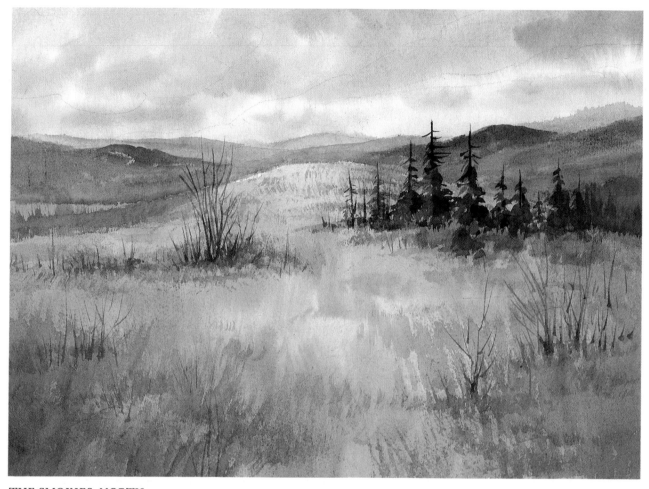

THE SMOKIES, NORTH
CAROLINA, 10 × 14″
This is a typical scene along
the Blue Ridge Drive. The
gentle slopes of the moun-
tains continue as far as the
eye can see. Keeping the de-
tail in the foreground and
background simple and
light gives the feeling of dis-
tance. The clouds, bigger at
the top and then getting
smaller, also help to create
the feeling of distance.

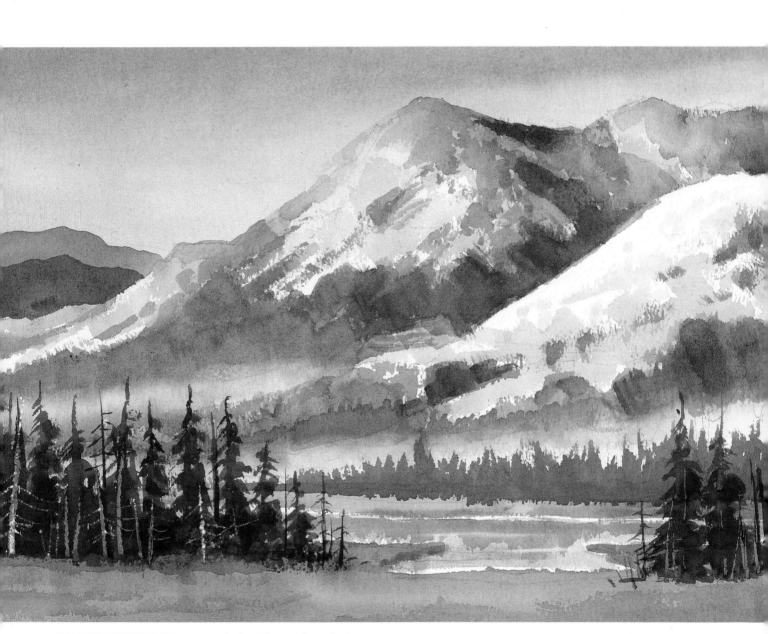

ROCKY MOUNTAIN HIGH, 10 × 14″
The rugged, snow-covered peaks of the Rockies can seem an overwhelming subject to paint at first, but you can simplify everything by painting the foregrounds and distant areas in alternating patterns of lights and darks. The patches of mist and the simple flat tones of the intermediate trees also help to communicate the idea of distance. The mist can be made by floating clear water or softly scrubbing away with a stipple brush.

FARMLANDS

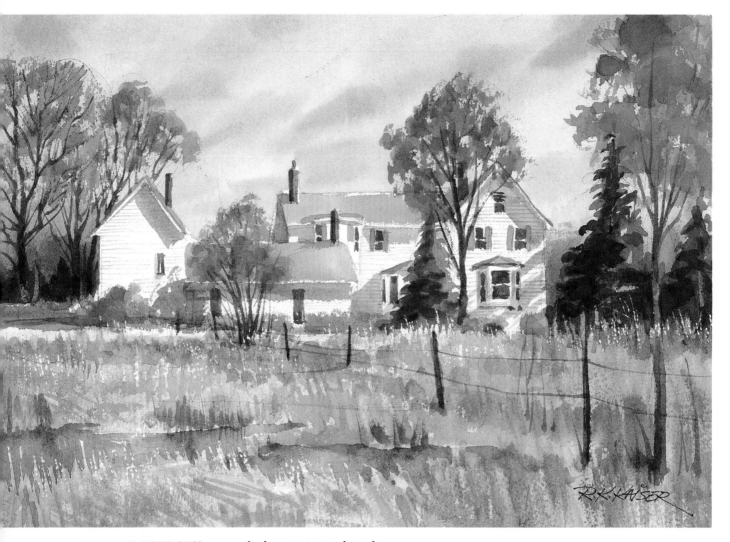

CHARLIE GORDON'S FARM, HAMILTON, NEW YORK, 10 × 14″
Here's a typical farm in upstate New York. After traveling around the United States, you become aware that each part of the country has its own local architecture. I've played the shadows strong to show the shape of the house and its structure. Notice in the tall grass the different shades of green, brown, yellow and even red. I've left an entrance of pure white on the left and picked up the white here and there to give a sunlit sparkle to the scene.

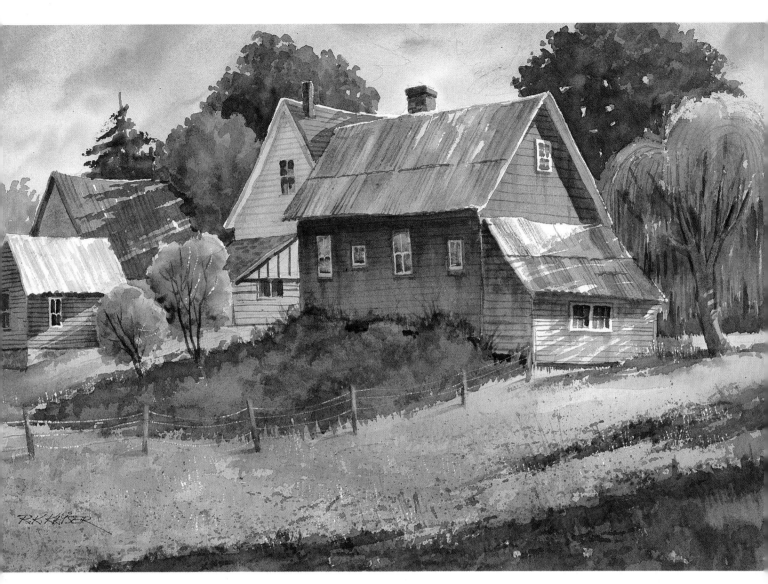

FARM, PURITY SPRINGS, NEW HAMPSHIRE, 15 × 22"

My friend Tony van Hasselt and I were in a car, scouting the area for a subject to paint in the next morning's class, when we came across this scene. We both said, "Ahh, this is it!" A great scene with all the prerequisites—varied textures, great cast shadows, numerous centers of interest, good trees, overlapping buildings, the sparkle of a sunlit wire fence, and much more. But best of all, it was paintable from many different angles. When you come across as good a subject as this, don't paint just one view. Take your camera and photograph all the other possibilities for future paintings.

FINAL THOUGHTS

I hope that the excursion we've shared in the preceding pages will inspire you to gather your watercolors, go outdoors, and paint all those scenes that stir your imagination and feelings. Throughout this book I've discussed my own ideas and experiences in watercolor, and I hope this will help you produce better paintings. But in the final analysis, you must paint your *own* way.

We all have many influences in our artistic lives. We admire other artists' work and may even be unconsciously affected by their outlook and style. There is nothing wrong with being influenced by the work of other artists. The danger is being influenced too much. Just be sure to put your own personal touch in your paintings. Go with what *you* see and feel about a scene. Your instincts won't usually fail you.

Zygmund Jankowski has said, "Each person has his or her own temperature gauge, and it will come out when you paint." This inner feeling is there whether you know it or not. You'll find you have your own "workhorse colors," colors you tend to use more than any other on your palette, whether it's blue, burnt sienna or cadmium red. Ask yourself, Which pan do I have to refill from my paints more often than any other? Your color choices express your personal style and viewpoint and are as valid as anyone else's.

Watercolor is a wonderful medium. Learn all you can about it: color, composition, technique, lighting—everything. But discipline and consistency are the elements that will ensure your progress in painting. You've got to paint, paint, paint. Someone once said, "You've got to do two thousand paintings and then, maybe, you'll start to paint." Now, don't panic. Maybe not quite two thousand! But, simply put: The more you paint, the better you'll get.

My friend Tony van Hasselt often cautions beginning artists against going out and trying to paint a masterpiece. Just go out to paint and have fun, and if you come back with a couple of good paintings, "that's gravy on the potatoes."

I hope the suggestions and the paintings in this book will help you be a little more confident about watercolor. As I've said many times, "If God has touched you with a little ability, you should pass the 'learning torch' along. Don't keep it to yourself!"

Keep painting, keep that brush wet, have fun, and if you see me painting outdoors, do come over and say hello! It's always great to meet fellow artists.

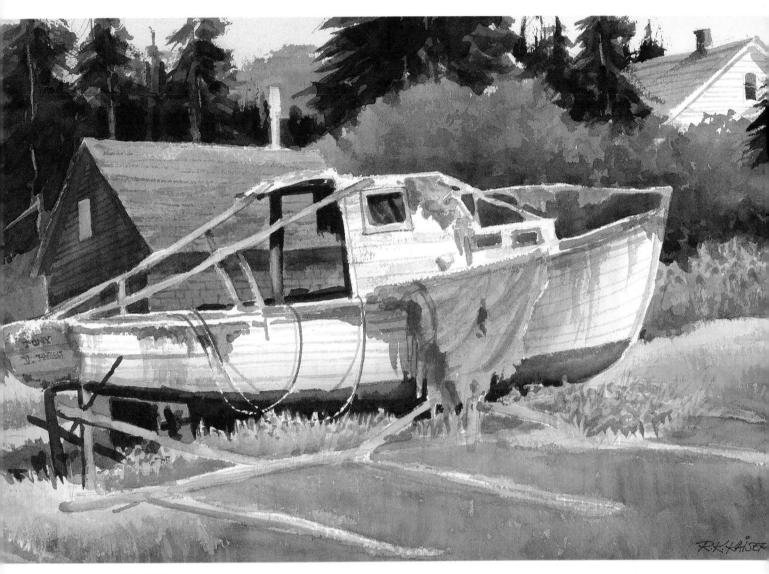

HIGH 'N DRY, PORT
CLYDE, MAINE, 15 × 22"

INDEX

Angles, 105
 considering all, in
 scene, 13
Autumn. *See* Fall

Backlight, 60-61, 77, 125
Bass Rocks, Rockport, Massachusetts, 39
Berkshire Farm, Massachusetts, 70
Blotting, 110
Bridge at Pocono Pines, Pennsylvania, 125
Bridge, Kingston, New Jersey, 39
Brushes
 results with various, 8-9
 stipple, lifting with, 112
 types of, 6-7
By the Stream, 53

Camera, for reference photos, 12, 22
 See also Photos
Captain Two Bill's, Savannah, Georgia, 66
Cast shadows. *See* Shadows
Center of interest. *See* Point of interest
Charlie Gordon's Farm, Hamilton, New York, 130
Chroma, defined, 48
Color wheel, 48
Colors
 basics of, 48-49
 fall, 54
 relationships of, 104
 seasonal, 50
 spring, 52
 summer, 53
 winter, 51
Composition
 defined, 24
 improving painting
 through, 104-105
Contour drawing, 34
Cottage on the Hill, 52
Covered Bridge — Swiftwater Inn, Pocono Pines, Pennsylvania, viii-1
Critique, of work, 102-105
Cropping, to correct painting, 107
Cumberland, Maryland, 15

Demonstrations, step-by-step, 42-45, 80-99

Depth
 achieving illusion of, 87-91
 creating, with value relationships, 103
 using colors to achieve, 48
Directional lines, 105
Distance, creating, 128
Drawing
 contour, 34
 detail, 36
Drybrush
 achieving effect of, 9
 sharp edges with, 30

Easels, 11
Eastern Lighthouse, Gloucester, Massachusetts, 23
Edges
 sharper, with drybrush technique, 30
 soft, with stipple brush, 112
 straight, working with, 111

Fall, colors of, 54
Fall and Barn, 54
Fall at Washington's Crossing, Pennsylvania, 111
Farm on the Mountain, Pisgah, North Carolina, 50
Farm, Purity Springs, New Hampshire, 131
Farm, The, Dorset, Vermont, 3
Farm, Washington's Crossing, Pennsylvania, 83
Farmlands, painting, 130-131
Form, defining, with shadows, 124, 125

Georgetown, Washington, D.C., 126
Glazing, to correct painting, 108
Gloucester Harbor, 107, 121
Gloucester Street, Massachusetts, 90-91
Gorge Near Freedom, New Hampshire, 86
Gradation, creating illusion of reality with, 33
Grain Dispensing Warehouses, Oriental, North

Carolina, 21

*H. Madson . . . Workin'
 . . . Nantucket Island*, 108
High 'N Dry, Port Clyde, Maine, 133
House and Sheds, Freedom, New Hampshire, 56-57
House by the Tracks, Lambertville, New Jersey, 21
House on Defusky Island, North Carolina, 62
House on Main Street, Freehold, New York, 127
House on the Corner, Monmouth Junction, New Jersey, 112
House, Stonington, Connecticut, 58
Houses, Rockport, Massachusetts, 66
Hue, defined, 48

Indoors
 looking out from, 76-77
 painting, vs. outdoors, 36-37, 100, 102-103
Intensity, defined, 48

Kingston Bridge, New Jersey, 55
Kingston Railroad Tower, 58
Kritikos's Tavern, Greece, 72

Lanesville Inlet, Massachusetts, 109
Le Consulat, Montmartre, Paris, 72
Lifting, stipple-brush, 112
Light
 back, 60-61, 77, 125
 changing, 12
 color of, 49
 foggy, 64-65
 nighttime, 72-73
 outdoor vs. indoor, 36-37
 on rainy day, 68-69
 reflected, 74-75
 side, 62-63
 top, 58-59
 See also Twilight
Light, bright, 66-67
 with dark shadow, 92-95
Lights, and darks, evaluating, 20

Lines
 directional, 105
 with various brushes, 8
Locale. *See* Painting, outdoors; Scenes; Settings
Lumber Mill, Jefferson, New Hampshire, 52

Markers, preferred types of, 4
Masking
 with fluid, 11, 81, 85-86, 93-95, 97-98
 with postcard cutouts, 111
 with tape, 11, 113
Materials. *See* Supplies
Mendocino, California, 60
Miklous Farm, Illinois, 27
Miniwatercolors, 38-39
Misting, 110
Mountains, painting, 128-129

Near Greenbriar, West Virginia, 100-101
Negative spaces, 28
New Hampshire Farm, 70
Night scenes, 72-73
91 Swan Street, Lambertville, New Jersey, 38

Old Barns, 38
Old Gray #2, Rockport, Massachusetts, 25
Old One, 51
Outdoors
 looking, from inside, 76-77
 painting, 12-13
 vs. indoors, for painting, 36-37, 100, 102-103
Overcast conditions. *See* Light, foggy; Light, on rainy day
Overlapping, 28, 127

Paint, types of, 5
Painting
 cast shadows, 80-83
 creating depth in, 87-91
 critiquing, 102-105
 depth in, using colors to achieve, 48
 designing successful, 24
 entrances and exits of, 31

farmlands, 130-131
mountains, 128-129
outdoors, vs. indoors,
12-13, 36-37
seaside, 120-122
streams, 123-125
towns, 126-127
varied textures, 96-99
Palette, 10
Panorama, 41
Paper, 7, 10
putting ideas on, 11
*Pasture, The, Hamilton, New
York*, 53
Pastures of Ireland, 110
Pencils
preferred types of, 4
for watercolor papers, 11
Photos
panorama, 41
reference, 12, 22
using, 40
Pocono Pines Woods, 95
Point of interest, 20
as compositional factor,
105
targeting, 33
Positive shapes, 26
Postcard cutouts, 111
Primary colors, 48

*R.J. Olsen's Shack, Cushing,
Maine*, 76
*Rain on Rockport, Massachu-
setts*, 68
Reference photos, 12, 22,
40
Reflected light, 74-75
*Rocks Near Rockport, Massa-
chusetts*, 120

Rocky Mountain High, 129
Scenes
evaluating, 20
practice, 114-117
sample sketches of,
16-17
See also Settings
Scrubbing, 109
Sea, painting by, 120-122
Season, colors of, 50
See also Fall, Spring,
Summer, Winter
Secondary colors, 48
Settings, 118
Shadows
cast, painting, 80-83
changing, 12
dark, with bright sun-
light, 92-95
defining form with, 124,
125
Shapes, arranging, 26-31
Shapes, and sizes
evaluating, in scene, 20
varying, 105
*Shrimp Boat, Hilton Head
Island, South Carolina*,
60
Side light, 62-63
Silhouettes, 29
Sizes. *See* Shapes, and sizes
Sketch
quick, 34
three-value, 32-33
value, 12-13
See also Drawing
Sketchbook, 4
*Smokies, The, North Caro-
lina*, 128

Snow-Bound Stream, 106
Spaces, negative, 28
Spatter
brush for, 9
tape and, 113
Sponge, 10
See also Scrubbing
Spring, colors of, 52
Spring House, Pennsylvania,
124
Stipple-brush lifting, 112
*Stream, Pisgah Mountains,
North Carolina*, 123
Streams, painting, 123-125
Studies, practice, 114-117
Studio, working in, vs. out-
doors, 36-37, 100,
102-103
Subject, choosing, 14
Summer, colors of, 53
Sun. *See* Light
Supplies
for correcting painting,
106
drawing, 4
miscellaneous, 10-11
*Swan Street, Lambertville,
New Jersey*, 46

Tangent, avoiding creation
of, 105
Techniques, correcting,
106
Temperature, of color, 104
Textures, painting, 96-99
Top light, 58-59
Top of the Hill, 118-119
*Top of the Hill, Rockport,
Massachusetts*, 68
Towns, painting, 126-127

Twilight, 70-71
*Two Boats in Marsh Woods,
Chesapeake Bay*, 78-79

Value sketch, 12-13
defined, 31
Values
arranging, 32
defined, 48
dominant, importance
of, 104-105
relationships of, 103
sketching with three,
32-33
See also Lights, and
darks, evaluating
Variety, of shapes, impor-
tance of, 26
Viewfinder, using, 18-19
Vignettes, 30
Visual barriers, avoiding,
31

*Walking Bridge, Lenox, Mas-
sachusetts*, 99
*Watercolorist's Complete
Guide to Color, The*, 104
Watercolors, mini, 38-39
*Weighing Shed, The, Port
Clyde, Maine*, 76
Weight, as compositional
factor, 105
Wharf at Port Clyde, Maine,
122
Whites, saving, 33, 84-86
Winter in New Hampshire, 51
Winter, colors of, 51
*Workday at Crisfield, Mary-
land*, 113